the photographer's guide to
San Francisco

Where to Find Perfect Shots and How to Take Them

Lee Foster

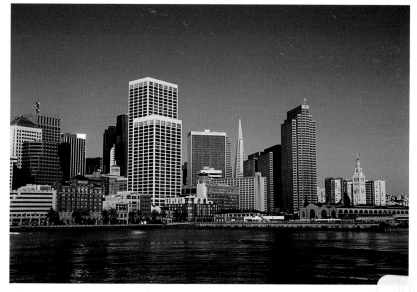

THE COUNTRYMAN PRESS
WOODSTOCK, VERMONT

ISBN 978-0-88150-814-7

Cover and interior photos by Lee Foster
Book design and composition by S. E. Livingston
Maps by Paul Woodward, © The Countryman Press

Published by The Countryman Press,
P.O. Box 748, Woodstock, VT 05091
Distributed by W. W. Norton & Company, Inc.,
500 Fifth Avenue, New York, NY 10110

Manufactured in Malaysia

10 9 8 7 6 5 4 3 2 1

Frontispiece: *Downtown San Francisco as seen
from the early-morning ferry to Oakland*
Right: *Art-deco detail inside the Paramount
Theatre, Oakland*

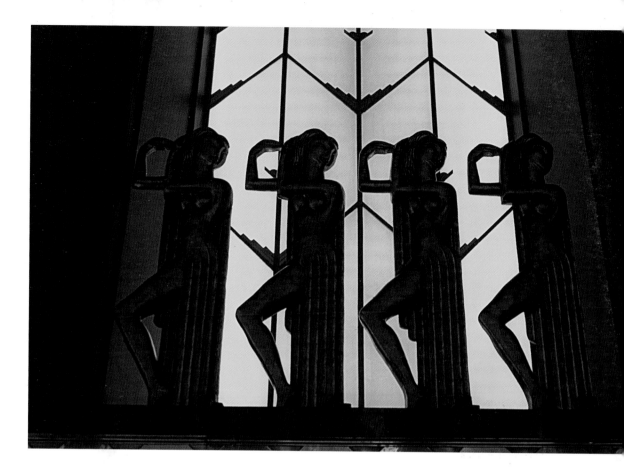

This book is dedicated to my children—
Bart, Karin, and Paul—and to their families,
with whom I enjoy exploring San Francisco

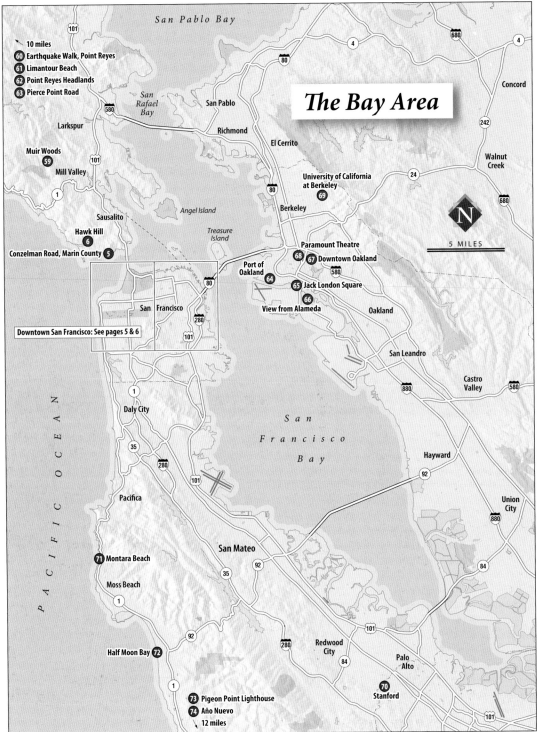

San Pablo Bay

101

↖ 10 miles
60 Earthquake Walk, Point Reyes
61 Limantour Beach
62 Point Reyes Headlands
63 Pierce Point Road

San Rafael Bay

580

Larkspur

Muir Woods
59

101

Mill Valley

1

Sausalito

Hawk Hill
6

Conzelman Road, Marin County 5

Angel Island

Treasure Island

San Pablo

Richmond

El Cerrito

80

University of California at Berkeley
69

Berkeley

The Bay Area

Concord

242

Walnut Creek

24

680

N

5 MILES

Port of Oakland

Paramount Theatre
68 67 Downtown Oakland

64

580

65 Jack London Square

66

View from Alameda

Oakland

San Leandro

880

Castro Valley

580

80

San Francisco

280

101

Downtown San Francisco: See pages 5 & 6

1

Daly City

35

280

101

Pacifica

P A C I F I C O C E A N

71 Montara Beach

Moss Beach

1

Half Moon Bay 72

1

73 Pigeon Point Lighthouse
74 Año Nuevo

↙ 12 miles

S a n
F r a n c i s c o
B a y

Hayward

92

Union City

880

San Mateo

35

92

84

92

280

101

Redwood City

84

Palo Alto

70
Stanford

101

Paul Woodward, © The Countryman Press

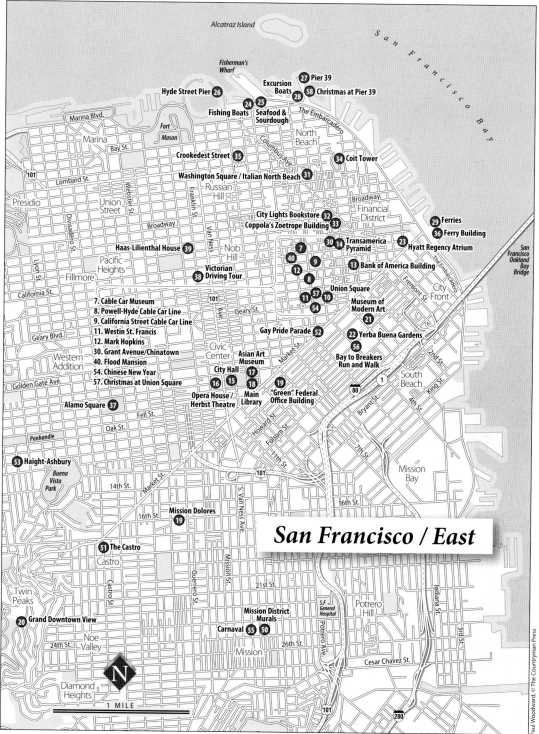

Alcatraz Island

San Francisco Bay

Fisherman's
Wharf

Hyde Street Pier 26 Excursion
 Boats 27 Pier 39
Fishing Boats 24 25 28 58 Christmas at Pier 39
 Seafood &
 Sourdough The Embarcadero

Marina Blvd. North
 Beach
Marina
 Bay St.
Fort
Mason
 Crookedest Street 35 34 Coit Tower
101
Lombard St. Washington Square / Italian North Beach 31

Presidio Union Russian
 Street Hill
 Broadway Broadway
 Financial
 City Lights Bookstore 32 District
 Coppola's Zoetrope Building 33 29 Ferries
Haas-Lilienthal House 39 36 Ferry Building
 Nob 30 Transamerica 23
 Hill 7 14 Pyramid
Pacific 40 Hyatt Regency Atrium
Heights 9
 Victorian 13 Bank of America Building
California St. Driving Tour 38 12
 8 City
7. Cable Car Museum 101 Front
8. Powell-Hyde Cable Car Line Geary St. Union Square
9. California Street Cable Car Line 11 57 10 Museum of
Geary Blvd. 18 Modern Art
11. Westin St. Francis 54
12. Mark Hopkins 21
30. Grant Avenue/Chinatown
40. Flood Mansion Gay Pride Parade 52
Western 22 Yerba Buena Gardens
Addition 56
54. Chinese New Year Asian Art Bay to Breakers
57. Christmas at Union Square Museum Run and Walk
Golden Gate Ave. Civic 17
 Center City Hall 80 South
 16 15 1 Beach
Alamo Square 37 18
 Opera House / Main 19 "Green" Federal
 Herbst Theatre Library Office Building
 Bryant St.
Fell St.
Oak St.
Panhandle

53 Haight-Ashbury Mission
Buena Bay
Vista
Park 14th St. Market St.
 16th St.
 16th St. Mission Dolores
 19

51 The Castro
Castro Potrero
Twin Hill
Peaks Castro St. 21st St. S.F.
 General
 Hospital
20 Grand Downtown View Mission District
 Noe Murals
 Valley Carnaval 55 50
24th St. 26th St.
 Mission Cesar Chavez St.

N
Diamond
Heights
1 MILE

San
Francisco
Oakland
Bay
Bridge

San Francisco / East

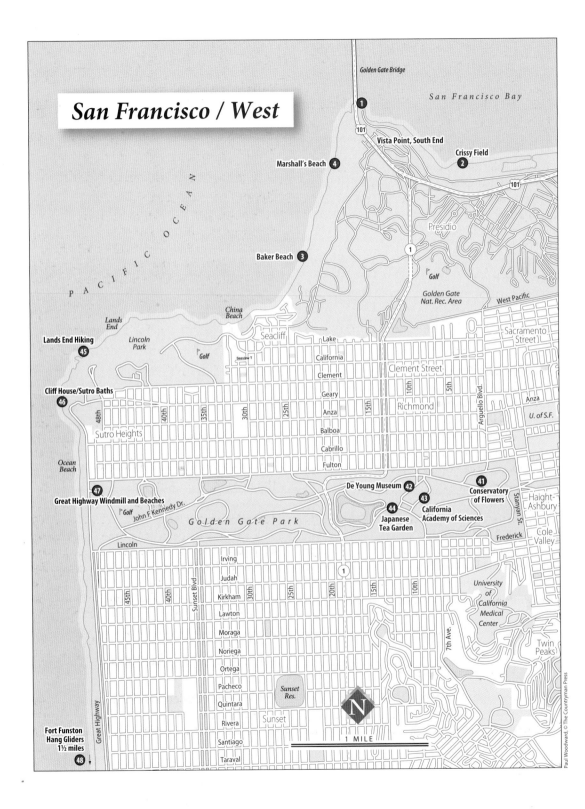

San Francisco / West

Golden Gate Bridge

San Francisco Bay

1

101

Vista Point, South End

Crissy Field

Marshall's Beach 4

2

101

Presidio

Baker Beach 3

1

Golf

Golden Gate
Nat. Rec. Area

West Pacific

China
Beach

Lands
End

Seacliff

Lands End Hiking

Lincoln
Park

Lake

Sacramento
Street

45

California

Golf

Seaview T

Clement Street

Cliff House/Sutro Baths

46

48th

40th

35th

30th

25th

California

Clement

Geary

10th

5th

Anza

Anza

15th

Richmond

Arguello Blvd

U. of S.F.

Sutro Heights

Balboa

Cabrillo

Ocean
Beach

Fulton

De Young Museum 42

Conservatory
of Flowers

41

Great Highway Windmill and Beaches

47

43

California
Academy of Sciences

Staryan St.

Haight-
Ashbury

Golf

44

John F. Kennedy Dr.

Japanese
Tea Garden

Frederick

Cole
Valley

Golden Gate Park

Lincoln

Irving

Judah

University
of
California
Medical
Center

45th

40th

Sunset Blvd

30th

25th

20th

15th

10th

Twin
Peaks

Kirkham

1

Lawton

Moraga

Noriega

7th Ave.

Ortega

Pacheco

Sunset
Res.

N

Quintara

Rivera

Sunset

Great Highway

Fort Funston
Hang Gliders
1½ miles

Santiago

1 MILE

48

Taraval

Contents

Carved details enliven the sandstone architecture at Stanford University

Introduction

San Francisco may well be the most photographed city in the world. Almost everyone who comes here, from the casual traveler to the dedicated pro photographer, has an urge to capture its images. This book hopes to address your visual aspirations—whatever they may be—and enhance your encounter with the City, as San Franciscans like to call their urban area. Maybe you have a camera at the ready and want to snap some vivid memories. Maybe you are a pro photographer intent on improving your San Francisco portfolio. Or maybe you just want to know where to look for some intriguing views.

First, consider the beauty of the physical setting: hills flanked by ocean and bay with the green expanse of Marin County to the north—almost begging a viewer to break out the camera. Give in to the urge and get out and walk along one of the great urban paths in the world, appropriately named the Golden Gate Promenade, with the Golden Gate Bridge in view. Beyond this, some of the best views are from the water, and any visitor who fails to take a Blue & Gold excursion boat out on the Bay from Pier 39, opening up lovely vistas of the City, will leave visually impoverished.

Second, capture the special cultural freedom of San Francisco. The City was born almost overnight. With the 1848 Gold Rush, a bucolic Spanish mission town was transformed into a major city, and the people who came here from all over the world were energetic, progressive folks. Often the well-educated second sons of prosperous families who wouldn't inherit the ancestral farm or business were sent to the Gold Rush, with strong familial backing, to create a new family prosperity in California. From those early beginnings as a port and immigrant city, San Francisco has always been open to the flavors of the world, and many of the more recent influences have been from Asia and Latin America. Given the diversity in San Francisco, it's easy to find ethnically or culturally edgy images to photograph, whether the iconic and accessible foreignness of Chinatown, the Precita Eyes murals of the Mission District, or the gay culture of the Castro.

And third, the pervasive reality of San Francisco is that people are having fun and experiencing the good life—and joy and fun are worth recording with a camera. Here, those who prepare your meals consider themselves celebrity chefs rather than short-order cooks. The winemaker sees himself (or herself) as an artist whose work appears in your glass rather than on a wall. Visitors to San Francisco are likely to be enjoying themselves as much as the residents. There are good reasons why every travel magazine's poll of "What is your favorite city?" finds San Francisco if not at the top of the list, then at least in the top five. San Francisco in the 21st century is a special America.

Whether you're a photo pro, a dedicated amateur photographer, or a traveler intent on visualizing San Francisco, this book will help you succeed in your mission: capturing terrific, lively images of San Francisco.

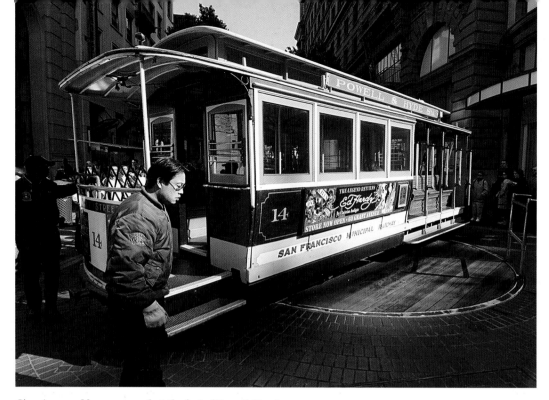

Turning a cable car around at the foot of Powell Street

Using This Book

My 10 Favorite Photographic Themes in San Francisco

San Francisco is a manageable and approachable city, roughly 7 miles by 7 miles, with a low-rise footprint over much of it—quite unlike daunting Manhattan, by contrast. But San Francisco is also so complex and diverse that it is helpful to have a thematic approach when you want to make photos. To that end, I have structured this book into 10 parts, representing my 10 favorite photographic themes in San Francisco.

Maybe the renowned cable cars will be your prey one day. Where should you look at them and when? Perhaps wandering the streets of Chinatown to experience one of the largest Chinese enclaves outside Asia will be your goal. Where might you find the details that are the essence of Chinatown? What will you experience district to district, season to season? This book offers specific perspectives, telling you exactly where and when to go to get the great views of this stellar city.

Beyond my specific suggestions, you will make your own special discoveries. That is the nature of a visual adventure: the serendipitous moment when something remarkable appears before you. Aside from recording it in your mind, you might also trip the shutter of your camera, preserving that revelatory moment forever.

How I Photograph San Francisco

I live in Berkeley, across the bay from San Francisco, and like millions of people in the region, I venture into the City occasionally. Often I board the BART underground train in Berkeley and step off in San Francisco near Union Square. What makes my periodic expeditions a bit more unique is that I visit specifically to create photographs. In many ways, though, I am just like the traveler, the tourist, who has just stepped outside their hotel with camera in hand. The City awaits.

Here are some main things I consider when photographing San Francisco:

Photo Excursions Enhance Life

I may be going into San Francisco for a narrow purpose—such as an assignment from a travel publication—but I always try to see this type of photography in the larger context of enhancing my life. Maybe I'll be walking along the newly renovated bay-front path at Crissy Field from the St. Francis Yacht Club to the Golden Gate Bridge (see Part I). This is one of the great urban walks on the planet, and while I will get some specific photos, my larger purpose is to experience this magnificent setting.

Like many photographers, I find that the act of photographing forces me to focus (no pun intended) on what is essential in the setting. Capturing the details and the overall perspective that make a setting special is my quest. Maybe I'm there to look at the City's superb Victorian houses (see Part VI). Or maybe I ventured out to see the wonderful murals that Hispanic artists associated with the Precita Eyes gallery have painted in the Mission

Lands End, with the Golden Gate Bridge in the distance

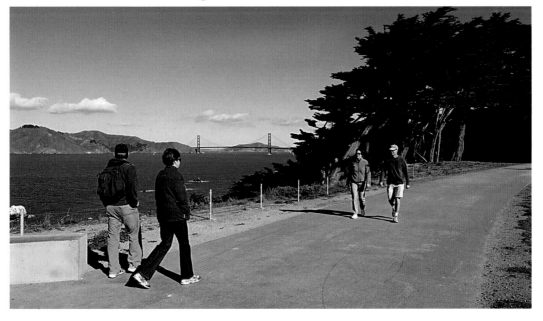

District (see Part VIII). Whatever the specific objective may be, I always try to make my pursuit more than just finding the perfect shot. And I often return home feeling that I better understand an aspect of this great city, San Francisco, and that my life has been enhanced.

It is hoped that the suggestions in this book will allow you to emerge after a photo reconnaissance with a satisfying sense that you have learned something significant or delighted in something special, further deepening your joy as a participant in the human drama. May the images you capture with your photography enhance *your* life.

Gear Is Key

The rapid development of the modern digital camera makes the vision of the person taking the photograph more critical than the tool of capture. A modest $250 to $500 point-and-shoot 6- to 12-megapixel digital camera available today surpasses the highest quality film or digital-capture tools a professional would have used only a few years ago.

Remember that some of the greatest photographers disciplined themselves to work in rather narrow technical ranges. Consider the magnificent Henri Cartier-Bresson, who did his major work armed just with a 50mm lens. He put his energy into developing his eye and his framing within this fixed rectangle.

Whatever camera you use, get comfortable with it. Practice with it before you actually need it. Nothing is more frustrating than losing an important image capture because you didn't have the technical details down pat. Record your digital images in the largest file size possible and in the format that will give you greatest

WPA mural, Coit Tower

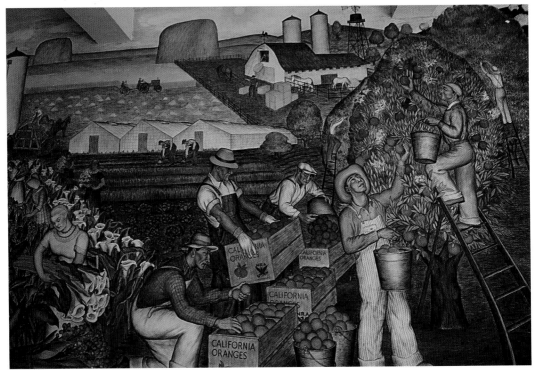

flexibility, which will be "raw," if that is an option with your camera. Then, just as you would have dipped your fingers into developing chemicals a generation ago, you can go into Photoshop (or some comparable program) and "interpret" your digital "negative" to the highest level of nuance you prefer.

As for my gear, I use two Nikon D200 bodies, one with a Nikon 12–24mm lens and the other with a Nikon 18–200mm lens. This is the combination with which I now do most of my professional travel journalism work. I never take the lenses off the cameras—except when I occasionally drop and break them, which does happen. I keep the lenses on to prevent dust from getting on my sensors.

The 18–200 lens has a "vibration reduction" feature (also known as image stabilization, or IS), which helps with low light. I set my sensor speed to 100 and shoot mostly in the Program mode, clicking on the ISO Auto function, allowing the light sensitivity to go up to 1,600 as needed in low-light interior situations.

I take my tripod to use in San Francisco when I can, but I am often involved in long walks and rough shooting situations, so weight and bulk are substantial issues. Basically, I compromise: when I can shoot close to the trunk of my car, I engage my tripod.

Layer for Comfort

My clothing "gear" is as important as my cameras. Remember that we are photographing San Francisco. Mark Twain's famous comment spoke volumes when he said, "The coldest winter I ever spent was my first summer in San Francisco." The City can be windy and chilly year-round, with fog on summer mornings and rain in any month from November to March. And when it isn't foggy and rainy, there can be intense sun and heavy wind, so one needs a hat that will not blow off. Moreover, San Francisco is hilly, placing a priority on comfy shoes.

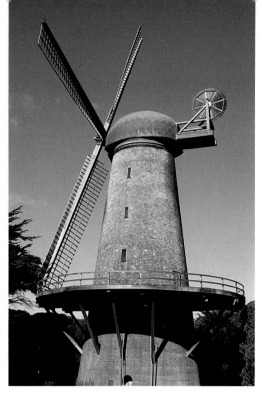

The Dutch Windmill, adjacent to the Great Highway beaches

Over the years I have gradually put in place a clothing default system, ready for all occasions, so I don't think about or worry about these things. I have comfortable Clark's walking shoes—dressy but totally durable. I like Tilley hats, with their secure chin straps. I have a red shell jacket and a red flannel outer shirt (red is a good modeling color) that always accompany me.

My camera equipment, too, has purely functional wear. I pack my cameras into a sturdy, nondescript black Domke OutPack backpack devoid of any advertising proclaiming that I'm a photographer. San Francisco does not have the theft or assault risk of a Rio de Janeiro or a Quito, but why push my luck? In my backpack I always carry a folded waterproof poncho good for heavy rains and winds. Two Ziploc bags are set to protect my cameras from rain,

Colorful ceiling and altar of Mission Dolores

blowing sand, and the insidious salt spray that may occur on San Francisco Bay or at Baker Beach on the west side of the Golden Gate Bridge. A folded large black trash bag prepares me for torrential downpours when the entire backpack needs to be protected. My final bit of gear is a small spiral-bound notebook with a slim pen tucked into the spiral, allowing me to make notes of my photo locations.

With this gear at the ready, I can travel almost anywhere in the world. That and a cell phone in case I want to call a taxi.

Be Mindful of Light and Season

San Francisco, which is located on a peninsula jutting northward, offers photographers different light for all hours and seasons. The sun sweeps across this unique urban canvas with a higher angle in summer and a lower angle in winter. Most of the streets have a north-south or east-west orientation. A soft morning light from the east and south falls on the skyline and on the Golden Gate Bridge. The glow of afternoon light can be felt on the western beaches and on the Golden Gate Bridge, especially as seen from Baker Beach in the City or from Conzelman Road in the Marin Headlands. In summer, expect heavy morning fog that will burn off but may creep back by 4 PM.

These variables can be used to artistic advantage, of course, such as capturing the east-west-running California Street cable car near sunset, with the cable car at the top of a hill at the intersection California and Jones (see Part II).

Some of the loveliest days to photograph the City and its environs occur in April and May, when rains have cleared the air of particulates, and the light has a special sharpness. September and October have a similar sharp light as autumn winds clear the air.

If you want light in the downtown canyons, such as around Union Square, 11 AM to 3 PM will be the most useful times, and summer will be more effective than winter. The winter sun is low and angular, creating a world of shadows, but the summer sun ranges overhead. Rain can be expected at any time from November to March, and it may be momentary or last for several days. (Fortunately, temperatures are moderate year-round, though the combination of wind, rain, and fog can make the atmosphere chilly at any time.)

Remember that you are photographing light on objects rather than the objects themselves, and the light in San Francisco has so many variables that it is never the same twice. The City has a wonderful resilience of shape and form, appearing with a chameleonlike range of complexity. The great English writer Samuel Johnson said, "When a man is tired of London, he is tired of life." Let me paraphrase that by saying, "When a photographer is tired of San Francisco, he is tired of life."

Enlarge Your Visual Vocabulary

Part of the pleasure of photographing a multifaceted and beautiful city like San Francisco is that you can repeatedly return—often to the same place—and find something new and exciting. Of course, the light and season will always be different. But so will be our own "visual vocabulary," the range of imagination and ideas that we present when we photograph or simply observe. We can continually enlarge our visual vocabularies.

Look over a postcard rack, or thumb through photo books about San Francisco (at, say, the **Barnes & Noble** in the Fisherman's Wharf area), and absorb the positions taken by some of the premier local photographers (who can lie in wait at any time of year for the perfect light). Could you go to the same places and

capture a scene in a more appealing way? This book will give you your best shot at surpassing even these pros.

Check out the alluring photography in major travel magazines, and try to envision how you might capture San Francisco in a new way. Maybe a detail in Chinatown, such as a rack of roasted ducks hanging up to dry, captures the essence of the place. Or when that silver-painted street entertainer stands in front of you at Fisherman's Wharf, crouch low to the ground and shoot the busker with the blue sky in back: a new angle, a simplified background that avoids the likely background clutter of a typical shot.

Strategize Transportation

Planning your transportation for a San Francisco photo outing involves several choices. One mode of transportation, cable cars, is also a special subject to photograph. You will be mesmerized by the huge wheels at the Cable Car Museum (see Part II). A combination of cable cars and your feet can get you around the northeast section of the city fairly well.

If you want to venture farther south—to, say, 24th and Mission Streets to view the special Precita Eyes Murals of the Mission District—the BART underground train can take you there.

Taxis can be useful in transporting you around the northern and western part of the City, and they are sometimes a critical part of the plan. For example, to experience the wonderful scenic walk along the Crissy Field promenade from the St. Francis Yacht Club to the Golden Gate Bridge, taking a taxi (rather than a car) to the yacht club as a starting point might be a good idea. That way you could take another taxi from the Golden Gate Bridge to your next destination and not have to walk back to your car.

Either a car or extended taxi support is useful for much of the western half of the city and

Silver-painted street performers at Fisherman's Wharf

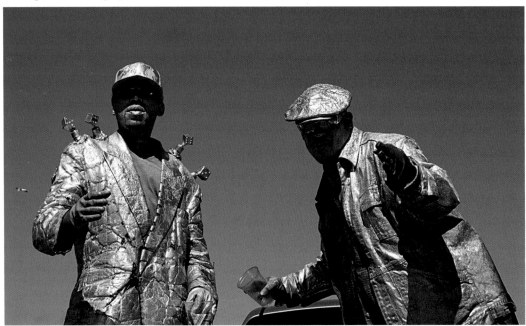

such stops as the Conservatory of Flowers in Golden Gate Park, the beaches west of the Golden Gate, and the lyrical hang gliders at Fort Funston. San Francisco has a bus system, but I have found it inefficient when it comes to the kind of erratic travel so typical of photo shooting.

Another option to keep in mind is renting a bike at Fisherman's Wharf. From the wharf you can literally bike to and across the Golden Gate Bridge and then take a ferry back from Sausalito. Or just pedal along the promenade at Crissy Field, stopping to photograph whatever strikes your fancy until you reach the bridge.

If you want to spend one day roaming on the cable cars, the cost of a ticket is $11. Consider getting a $54 CityPass ticket, which is good for seven days and includes not only all public transportation in the City but also many attractions and an excursion boat ride out on San Francisco Bay.

Speaking of which, excursion boat rides are a glorious mode of transportation to include in your planning. **Blue & Gold Fleet** boats leave adjacent to Pier 39 and make trips out on the bay and beyond to the other side of the Golden Gate Bridge, offering stunning photo opportunities of the city skyline, the bridge, the Marin hillsides, Alcatraz Island, and sailboats catching the wind.

Another Blue & Gold boat ventures over to the picturesque village of Tiburon, where you can catch yet another ferry to Angel Island. Circling Angel Island via tram or Segway affords remarkable views of San Francisco and the Golden Gate. Similarly, the excursion boat out to Alcatraz Island (now a national park and part of the Golden Gate National Recreation Area) offers both exciting views of the skyline and a look at one of the more draconian settings in our nation's penal history.

Whichever boat outing you opt for, make sure to include some from-the-water views

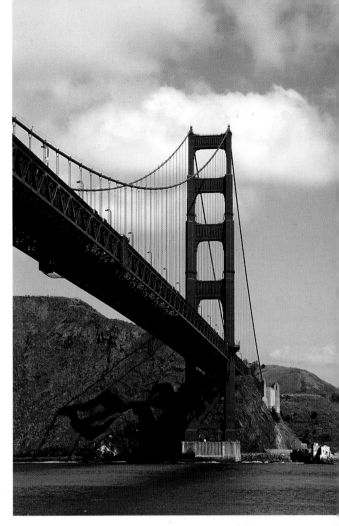

The downtown San Francisco skyline as seen from the ferry to Oakland

in your photo plans. Aside from the abovementioned excursion boats, ferries regularly depart from the historic **Ferry Building** over to Marin County and Oakland. Remember the light: San Francisco will be frontlit in the morning. Riding the Oakland-Alameda ferry as it pulls out of the Ferry Building in early morning can provide you with a luscious view of San Francisco's downtown skyline.

With this planning overview in mind, we can now venture out and begin to visually capture this remarkable city.

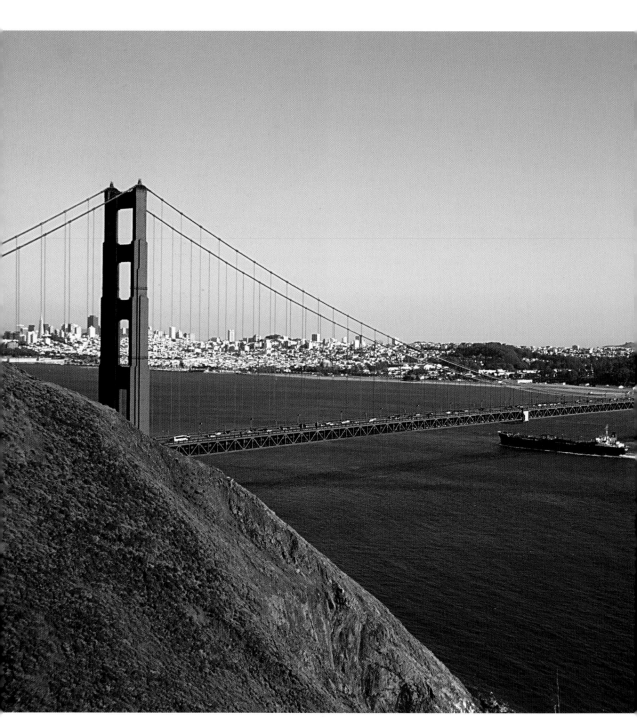

The Golden Gate Bridge as seen from the Marin Headlands

I. The Golden Gate Bridge

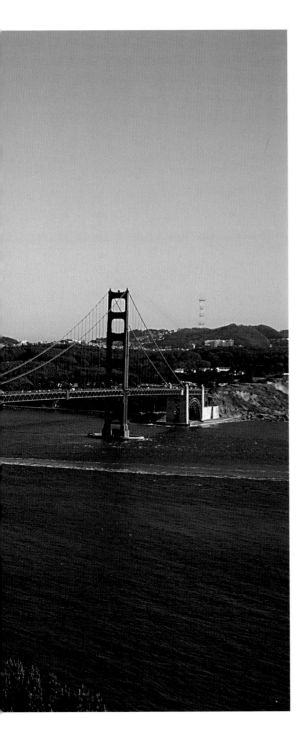

The first subject that a visitor will want to photograph in San Francisco is likely to be the Golden Gate Bridge, arguably one of the most lyrical and lovely creations in the long history of bridge building. There are more opportunities to photograph the Golden Gate Bridge than may be immediately apparent.

The first option should be a study of the bridge from Vista Point at the south end, seeing the bridge from the parking lot and perhaps from below by walking down to Fort Point. Beyond that, a "fresh-air" morning look at the bridge is presented to every walker who ventures out on the Crissy Field walkway, appropriately called the Golden Gate Promenade, extending from the Marina Green/San Francisco Yacht Club to the bridge. From west of the bridge, there are lovely afternoon and sunset views from Baker Beach and other beaches. A parallel afternoon/sunset view from Conzelman Road in the Marin Headlands will also delight a photographer. And finally, in Part IV of this book you'll find suggestions for obtaining views of the bridge from the water, in an excursion boat.

Let's look at all these options in more detail.

Vista Point, South End (1)

Vista Point at the south end of the bridge presents some magnificent views, especially from morning until midafternoon as the light falls on the vermilion-orange structure, whose paint color is officially described as International Orange. It isn't easy to park at Vista Point, so patience may be required. Perhaps consider getting there by taxi and either be dropped off or have the cabbie wait while you shoot.

Walk out to the overlook for vivid photos of the bridge. Then head down the path to the

historic Civil War–era Fort Point, where you can get water-level views of the bridge. Next, walk out on the east side of the bridge, or bike over to the west side of the structure to enjoy a scenic view of San Francisco. This east-side view is an effective later-afternoon image—not of the bridge but of the city itself.

At Vista Point, plantings of flowers can be incorporated into a bridge image. There, too, a bronze sculpture of the bridge's builder, Joseph Strauss, awaits you, along with a cross-section of bridge cable. With an adroit vertical wide-angle effort—assuming you can keep the crowd out—you can make a photo of both the bridge and the bronze Strauss. An action shot of a bicyclist ascending the path at the south end of the bridge, with the Golden Gate in the background, is another idea.

Much could be said of this object of our adulation. Perhaps most fundamental is that the creation of this bridge was an audacious act on many levels. At the time the structure was proposed in the early 1930s, its span was the longest of any suspension bridge, causing the engineering skeptics to scoff. Furthermore, no bridge had ever been attempted on a site where tidal pressure surges as powerfully as it does under the Golden Gate. The naysayers predicted that the bridge would fail catastrophically—and in the Depression era, financing the bridge was a long-term vote of confidence in a prosperous future that doubters derided. Ultimately the dreams of visionary San Franciscans prevailed, and construction began in January 1933. Completed in April 1937, this magnificent structure emerged as both a practical solution for traffic flowing to Marin County and as an aesthetic monument that has few parallels.

Crissy Field (2)

Crissy Field—the reclaimed former Presidio that's now part of the national park entity known as the Golden Gate National Recreational Area—runs from Marina Green to the Golden Gate Bridge. What was once a military airfield has been transformed into a congenial habitat, with native vegetation for birds and a wondrous promenade for humans. It offers excellent opportunities to get great shots of the bridge and action shots of people. Props available to you include the beach, the biking/walking path, and extensive grassy fields.

Joggers, bikers, and dog lovers can be seen on the glorious esplanade, which ranks as one of the great urban walks anywhere. The busy ship lane through the Golden Gate may also suddenly present for your camera the dramatic view of a container ship entering the bay. East Beach at Crissy Field affords your best opportunity for shots of windsurfing and parasailing. Especially from March to October, there is no lack of wind through the Golden Gate.

The morning light is especially pleasing for photos. Morning is generally also calmer, with wind picking up in the afternoon. By afternoon the bridge will be backlit as the sun continues westward. Take heed: If the weather is windy and blustery, be careful here of salt spray on your camera lens. A plastic Ziploc bag over your camera is recommended. Salt spray can be insidious and can permanently mar a lens if it's not immediately removed with a soft cloth. Blowing sand may also be scarcely noticeable but is always insidious, so protecting your camera gear is a good idea. Protect yourself from the wind, as well. Dress in layers when you visit Crissy Field.

Very early morning is a good time to photograph birds in the restored estuary environment and saltwater marsh at Crissy Field. Come with your longest lens and a tripod to steady it. Boardwalks around the estuary offer good shooting platforms. Herons and egrets are among the 135 species of birds that have been catalogued as visiting this reestablished marshland. Native California vegetation covers and protects the sand dunes around the estuary.

Consider carefully your photographic/outing strategy. If you walk the length of Crissy Field, you will end up at South Vista Point of the Golden Gate Bridge. It is also possible to rent a bike at Fisherman's Wharf and ride all the way through Crissy Field, across the bridge, and make a return trip by boat from Sausalito.

The **Warming Hut** restaurant and bookstore at the west or bridge end of Crissy Field is a good place for a rest stop and nutrition break during your outing. The old army shed that was converted into the restaurant was named for a reason!

The **Gulf of the Farallones Visitor Center**, on the pathway at Crissy Field, will interest the nature photographer. The visitor center is headquarters of the **Farallones Marine Sanctuary Association**, an organization dedicated to protecting the national marine sanctuary offshore.

Baker Beach (3)

From midafternoon through sunset, spectacular views—and therefore choice photos—of the Golden Gate Bridge and its setting are available from beaches on the western side of the Golden Gate in San Francisco and from bluffs on the Marin Headlands on the north side of the bridge. For these outings, you will want to have your own car.

Waterfront path at Crissy Field

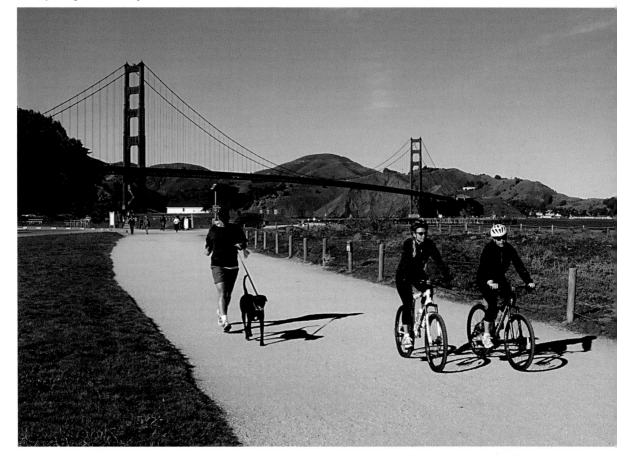

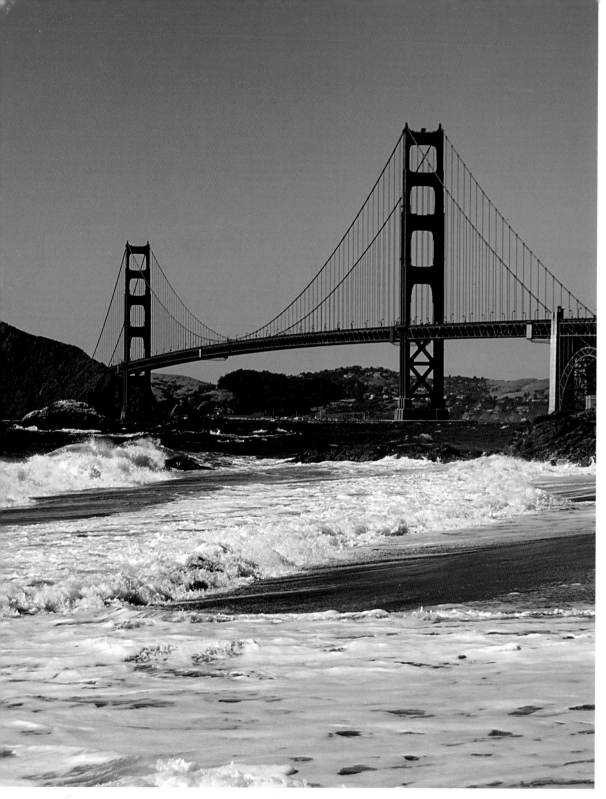

Surf and the Golden Gate Bridge as seen from Baker Beach

West of the bridge, the Baker Beach turnoff from Lincoln Boulevard is well marked. Here you'll find ample parking and direct access to the beach. Good shots can be made of the bridge in the distance with breaking waves in the foreground.

The beach is extensive, and many photo strategies can be employed. You can draw in the bridge with a long lens, or use a wide-angle lens to create vertical photos of the bridge and the surf. If the sky is clear, the afternoon light can be golden. If it's cloudy or foggy, the interplay of the setting sun on the clouds or fog can be dramatic.

My cover photo for this book is from Baker Beach, and you can replicate the image by getting to Baker Beach at about 3 PM on a gorgeous, sunny day. Once there, prepare to meditate on the scene for an hour. Walk from the parking lot toward the bridge until you see the image that pleases you. (It helps to have a tripod and rubber boots that allow you to stand in the surf.) The singular beauty of the bridge, the beach, and the surf is appealing. Optional amenities to bring—though essential for me— are a bottle of wine, some Brie, and a baguette.

One unusual aspect of the scene at Baker Beach will help orient you to the fact that you are in San Francisco. The "family" area of Baker Beach is near the parking lot. As you walk toward the bridge on a warm and sunny day, however, perhaps a thousand naked people will be cavorting in this salubrious environment. You'll need to be patient as you wait for the bridge and the surf to appear alone in your frame without naked people running into the surf. (The aforementioned bottle of wine can help.) Be respectful of naked people running through your photos. This is not the proper occasion to whip out your model releases. Though no thefts have been reported, it's best to have a colleague present to watch over your camera equipment if you decide, after getting your fabulous photo, to run naked into the surf yourself.

Marshall's Beach (4)

Closer beach access to the Golden Gate Bridge is also possible, but the trek to it requires some athleticism. Marshall's Beach is less well signed, and the walk to the beach is long and steep. The parking area is one of the first available as you travel west on Lincoln Boulevard from Vista Point at the south end of the bridge and is good for only a few cars. You'll know you're in the right place if you see a National Park Service boardwalk leading toward the water. An extensive set of steps and paths, part of the glorious California Coastal Trail system, leads down to Marshall's Beach.

The experience is one of such extraordinary wildness that you'll wonder if you are still in San Francisco. But the vegetation is definitely Californian, with the blue-blossom ceanothus bushes especially fragrant in the spring. If you are equal to the physical demands of the steep ascent and descent on the steps, an extraordinary, secluded pocket beach awaits you at the bottom. Fairly close-up shots of the bridge from water's edge in afternoon and sunset light are possible.

Conzelman Road, Marin County (5)

Grand afternoon and sunset views of the Golden Gate Bridge are easily accessible from the Marin County side. Drive across the bridge, and take the first turnoff, which is Sausalito, and then turn west on Conzelman Road, which snakes along the Marin Headlands bluffs. The first two turnoffs here are especially recommended.

The first turnoff, immediately above the north tower of the bridge, amounts to a walk out to Battery Spencer and a close-up view of the span. A vertical photo of the north tower is possible from here. Another visual concept juxtaposes the military fortifications that remain

from World War II and the bridge. Following the hysteria of Pearl Harbor—when there was substantial fear that Japan would mount a mainland invasion, with San Francisco as the target—the Marin Headlands hillsides were heavily fortified with gun emplacements. Today the guns themselves are gone, but their concrete bunker support systems are a sobering reminder of the World War II era.

The second turnoff, a quarter mile to the west, is the classic view of the Golden Gate Bridge north tower with San Francisco in the background. This is a vertical image that is seen in every postcard collection about the City. Hopefully, on your visit you will have ex-traordinarily good light in the hour before sunset. If the weather is clear, the bridge will reflect a golden glow. If the weather is foggy or cloudy, you may just happen upon a dramatic sky.

Hawk Hill (6)

A third turnoff on Conzelman takes you to a justifiably famous site known as Hawk Hill, which is choice. Continue on the road west, and keep to the left, following the Point Bonita Lighthouse signage. Park where the two-lane road ends and a one-way road begins. This view is one of the most amazing promontories for a look at the Golden Gate, which is not just the bridge but also the entrance to San Francisco Bay. This view calls for a wide-angle horizontal photo encompassing the Golden Gate and the City.

At the parking turnoff at Hawk Hill, signage alerts you to the naming of this location. Credit falls to John C. Fremont, who played a decisive role in the critical years of the 1840s, when California could have evolved in any of several directions. In 1848 Fremont wrote of how, as a lieutenant in the U.S. Corps of Topographical Engineers, he came upon this scene and decided on the name: "Between these points is the strait about 1 mile broad in the narrowest point, and 5 miles long from sea to bay. To this gate I gave the name Chrysopolae, or Golden Gate." Fremont was referencing the fabled Straits of Bosporus and the Greek city Chrysopolis, which translates as City of Gold.

Aside from the extraordinary view, Hawk Hill is where many migrating West Coast raptors cross the Golden Gate, due to the favorable thermals. An informal count of raptors migrating each year becomes an index of the health of the western U.S. ecosystem. If your photographic passion is birds, especially raptors, you should definitely visit this place.

The view from Hawk Hill in the Marin Headlands

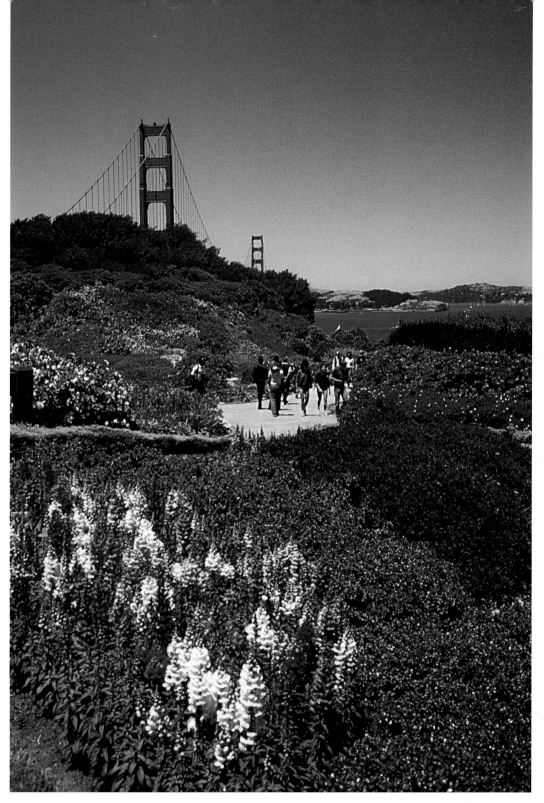

The iconic Golden Gate Bridge as seen from Vista Point

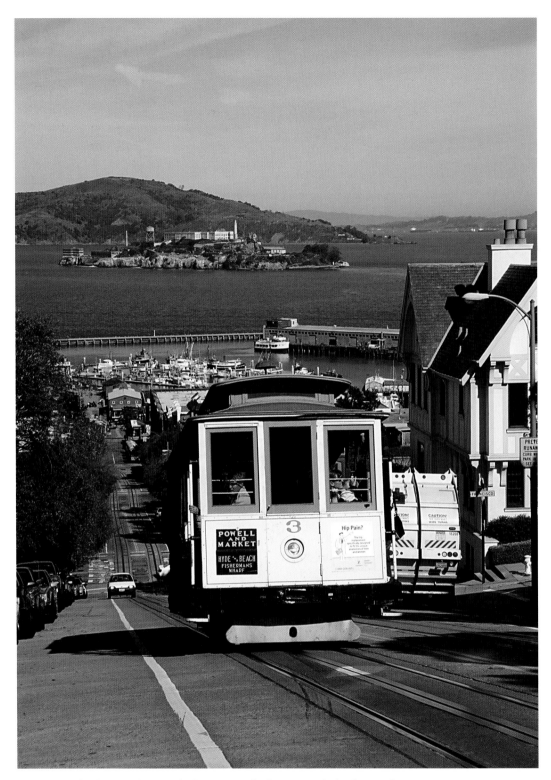

A cable car climbing Hyde toward Chestnut, with Alcatraz in the background

II. Cable Cars

San Francisco's cable cars are among the most photogenic and beloved aspects of the City. They also are a practical method of transportation in a city with some fairly steep hills.

As you begin your cable car excursion, pause for a moment to salute the visionary who conceived the system. His name was Andrew S. Hallidie, and his inspiration came from the many troubling scenes he witnessed on San Francisco's sharp, slippery inclines, especially during the rainy season. Horses hauling up a carriage or wagon would lose their footing, fall, and be dragged down the hill as the carriage or cart drivers and patrons tried to escape injury themselves by leaping from the mishap. The horses were often less fortunate and would have to be "put down." Deciding that there had to be a better way, Hallidie eventually invented the means to pull streetcars securely up the hills on steel cables. His inaugural street railway system, the Clay Street Hill Railroad, began service on August 2, 1873.

Cable Car Museum (7)

Orient yourself to the cable car phenomenon by going first to the Cable Car Powerhouse & Barn, officially known as the Cable Car Museum, at 1201 Mason Street. The building is both a museum and the working heart of the system. Outside, get a shot of a cable car passing this building. Inside, smell the gear oil and hear the noise of the four great wheels that wind the cables and pull the cars around the system and, if you believe the song, halfway to the stars. You can look down at these giant wheels and see the machine shop where iron artisans work on the specialized parts needed to keep the system operational. It is quite exciting to see the innards of the operation. If you don't have a tripod, you will want to increase the ISO of your digital camera to get interior shots, using a wide angle to capture the huge winding wheels. As you gaze down on the gear reducers, you'll note from the proud signature that the equipment is from 1892, built by the Philadelphia Gear Corporation, lending a historic aspect to this remarkable paraphernalia.

Wander around the main floor of this museum and admire the antique cable cars with wood finery and wrought-iron decoration. They make good iconic photos. There is also a wall devoted to the Great Earthquake and Fire of 1906, which destroyed the cable car system along with much of the City. Particularly intriguing are the movies from 1906, showing San Franciscans living in tent cities after fleeing the conflagration, which blazed unchecked for three days because all the water mains were broken. The fires were stopped only by dynamiting individual buildings in the fire path, creating firebreaks that the flames would not be able to jump.

After exploring the Cable Car Museum, it's time to hop aboard one of these vehicles and get some shots of two of the lines, Powell-Hyde and California Street.

Powell-Hyde Cable Car Line (8)

The most central place where visitors board the cable cars is at Powell and Market Streets, but you can board a cable car at any place along the line. (Tickets are $5 one way and $11 for an all-day pass. I recommend getting an all-day pass—better yet, get a $54 CityPass if you plan to explore for several days. The CityPass includes not only all public transportation but also entrance to several attractions and a boat ride on the bay.)

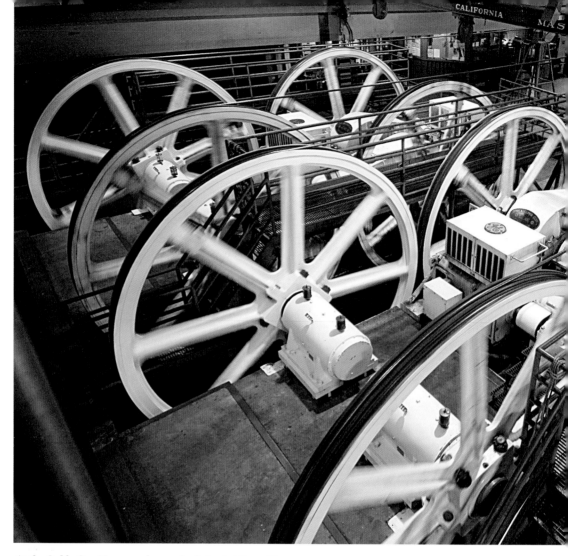

At the Cable Car Museum, huge wheels propel the cable cars

There are many places where boarding a cable car is less congested than at the foot of Powell Street, but this site is inviting because here you can make a photo of the train operators doing a hefty turnaround of the cars at the end of the line. Note that the line splits, with some cars going to Hyde Street and Aquatic Park and other cars going to Bay Street at Fisherman's Wharf.

Riding the entire length of this branch of the line will give you an extensive look at large areas of the City's northwest quadrant. You'll pass Union Street, a neighborhood worth exploring, as well as the famous Crookedest Street in San Francisco, Lombard Street. This is a good morning photo if you get off the cable car at Lombard and photograph it from the top or walk down to its base and shoot up, looking west.

The most classic photo of a cable car on the Powell-Hyde line is where Hyde crosses Chestnut. If you get off at Chestnut, at the top

ferent feel to it than the Powell-Hyde line and is well worth exploring. Ride it up California Street to pass through the City's heart of corporate power, the Financial District. Here, where movers and shakers will be hopping on and off the California Street cars, you can make effective photos of the cable cars and corporate San Francisco intertwined.

The busiest intersection of all at which to watch cable cars coming and going is on Nob Hill at Powell and California Streets, which is also well lit and exposed. Chances are you will find good light on the cars here at almost any time of the day, from one direction or another. If you want to photograph people up close on the cars, stand at the small police kiosk on the corner of Powell-California.

Walk three blocks west on California to Jones, which is the top of the hill, and another interesting photo concept presents itself. There, cable cars are poised just about as close as you will find with a clear-sky background, so you can make a photo of the cars with the sky behind them for an interesting silhouette. If the sky is particularly lovely at sunset, this is a classic shot to consider, either with a sunset glow on a car or a car as a silhouette, depending on the angle you choose. However, be extremely careful because auto traffic moves quickly on California Street, and you don't want to be standing in the middle of the road at the wrong time. If you position yourself in a crosswalk, you will need lucky timing to synchronize the allowable crossing time, the approaching cable car, *and* good light.

All the cable cars for all the lines need to begin and end their days at the Cable Car Museum, so another effective photo might be a car passing the barn.

of the steep Hyde Street hill, you can make engaging photos of cable cars climbing the hill, with the bay and Alcatraz in the background. Because of shading from trees and a tall building, it is best shot from noon to 2 PM so as to get some light on the west side and front of the cable car as it ascends the hill.

California Street Cable Car Line (9)
The California Street line, which starts at California and Market Streets, has an entirely dif-

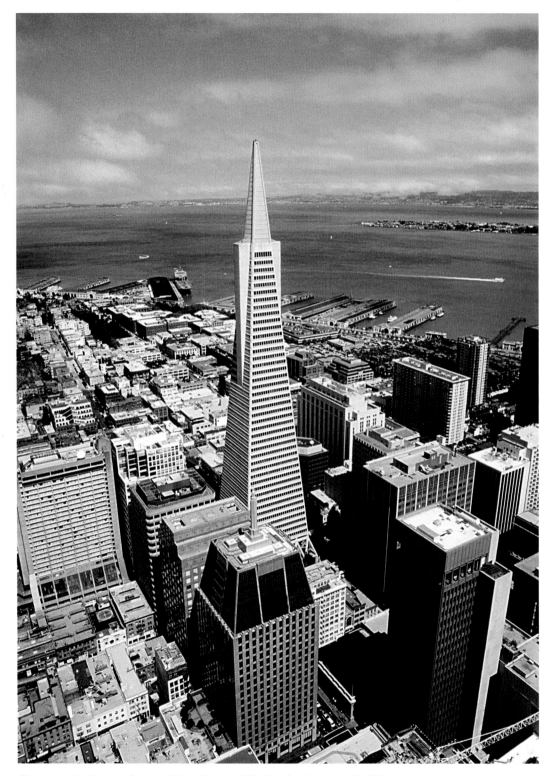

Transamerica Pyramid, viewed from the top of the Bank of America Building

III. Downtown

Downtown San Francisco presents many subjects that may delight a photographer, starting with the social and shopping focus, Union Square, which is only three blocks from the prime cable car turnaround at Powell and Market Streets. Northeast of Union Square is the Financial District, with two iconic buildings.

Also downtown, to the south and west, is a government district known as Civic Center Plaza. And to the south and east is the San Francisco Museum of Modern Art (SFMOMA) and its adjacent Yerba Buena Park. Here, too, you'll find the great hotels, which may be either classic historic subjects or examples of innovative modern urban design. Finally, the entire downtown scene can be perused from a promontory known as Twin Peaks.

Gather up your camera gear, and let's explore San Francisco's downtown.

Union Square Area

Union Square (10)

Union Square, starting at Geary and Powell Streets, is the retail commercial center of San Francisco, as contrasted with Montgomery Street, which is the banking/finance center. The square itself is a lively place to make photos. There may be an art show, street entertainers—who abound at Union Square and at the nearby plaza around the BART station at the foot of Powell Street—or just good candid subjects as San Franciscans lounge at the outdoor restaurant, Emporio il Caffè Rulli, and on the chairs, tables, and benches that surround the square. If there is a political rally or major happening in the City, there may be an expression of it at Union Square. Photographing in Union Square requires light. With the sun high, sum-

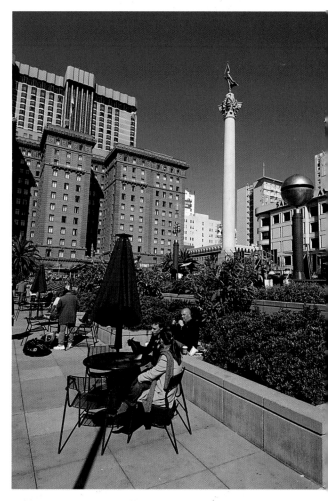

Relaxing in Union Square

mer shots will be best since winter's angular light in the urban canyons makes photographing more difficult. Also, morning light works better than afternoon light here.

Around the square and on the adjacent side streets are the major department stores, including Macy's, Neiman Marcus, and Saks Fifth Avenue—classic examples of the hustle and

bustle of shopping commerce. Walk Sutter Street to see many art galleries. At Post and Powell Streets, in morning light, you can make a clear shot of cable cars with the Westin St. Francis Hotel in the background—an opportunity for combining two icons in one photo.

The historic St. Francis Hotel—now the Westin St. Francis—at Union Square

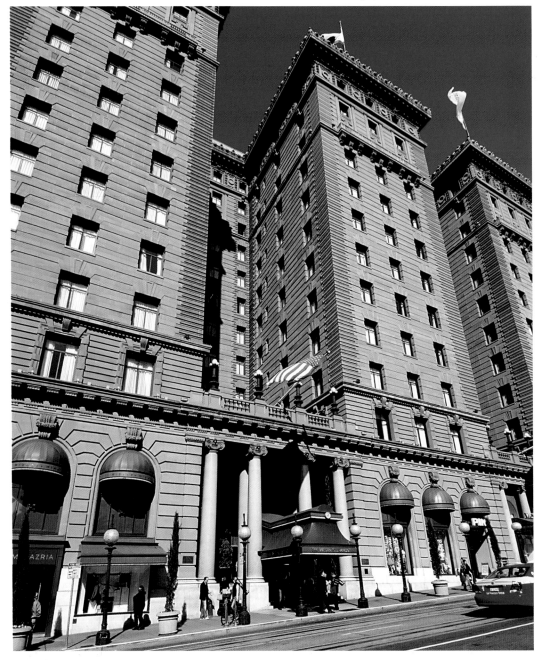

Westin St. Francis (11)

Landmark hotels reflecting the history and modern design culture of the city are another subject to consider for urban photos. The Westin St. Francis, at 335 Powell Street, will always have a special cachet because of its central location right on Union Square. The exterior makes a classic photo from across the street, possibly with a cable car going by, while the interior of the hotel is full of visual vitality. The **Michael Mina** restaurant off the lobby is cutting-edge for both cuisine and innovative urban design. And in the lobby at Christmas, there is always an engaging display of Christmas trees and a gingerbread Victorian castle to put a photographer in a holiday mood.

The St. Francis opened in 1904 as an investment by the estate of Charles Crocker, one of the "Big Four" railroad magnates. The structure was built so well that it survived the devastating earthquake of 1906. For generations of San Franciscans, the social phrase has been, "Meet me at the St. Francis."

Mark Hopkins (12)

The InterContinental Mark Hopkins, at 1 Nob Hill, is another major legacy property of which to be aware for photos. To photograph the Mark Hopkins is to photograph a bit of San Francisco history.

The choice site is at the southeastern peak of Nob Hill, where the railroad and silver barons lived—including Mark Hopkins, one of the founders of the Central Pacific Railroad, who decided to build his dream home for himself and his wife, Mary, at that spot. The mansion survived until 1906, when it weathered the devastating earthquake itself but was consumed by the conflagration that followed. An investor bought the property and created the ornate hotel, which continues to flourish at a rarified Four-Diamond level. Not to be missed: the enchanting views and photos of the City

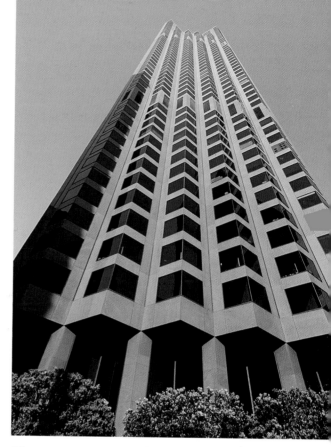

The Bank of America Building

from the famous top-floor restaurant/bar, the Top of the Mark

The Mark Hopkins is located opposite the **James Flood Mansion**, one of San Francisco's regal Victorians (see Part VI).

Financial District

The Financial District, a short walk north and east from Union Square, offers two special photo opportunities: the tall, monolithic Bank of America building and the triangular Transamerica Pyramid, the two most distinctive corporate architectural images in San Francisco.

Bank of America Building (13)

Get started for your best shot of the Bank of American building (555 California Street) by

positioning yourself with the sun behind you as you face the building. Pleasing photos can be made close up to the structure with a wide-angle lens, emphasizing its verticality. Then move back a block or two and find an uncluttered view of the structure.

Images of this celebrated monolith excite certain emotions in a San Franciscan. After all, this was once the venerable Bank of Italy, founded by A. P. Giannini, who carefully husbanded the modest savings of thousands of immigrants. Today it is the largest commercial bank in the U.S., as measured both by deposits and market capitalization.

Transamerica Pyramid (14)

The Transamerica Pyramid (600 Montgomery Street) is without question the most unusual commercial architectural building to photograph in San Francisco. The four-sided pyramid is covered in crushed quartz, which gives the structure its bright-white appearance. Completed in 1972, the Transamerica Pyramid is the tallest and most recognizable skyscraper on the San Francisco skyline. The concept of a pyramidal skyscraper takes a little getting used to, and San Franciscans first loathed architect William Pereira's design, though they later came to love it.

To photograph the Transamerica Pyramid, use the same approach that you did with the Bank of America. Start with a close-up, with the sun behind you, and then work your way back for a fuller view. Chances are you will emerge with an image that pleases you.

The origin of the pyramidal shape is steeped in local zoning lore. The property owners wanted a building taller than the rival Bank of America building at 555 California. However, the zoning laws restricted the allowable square footage of office space. The pyramid design solved the owners' dilemma

One unusual aspect of the relationship of

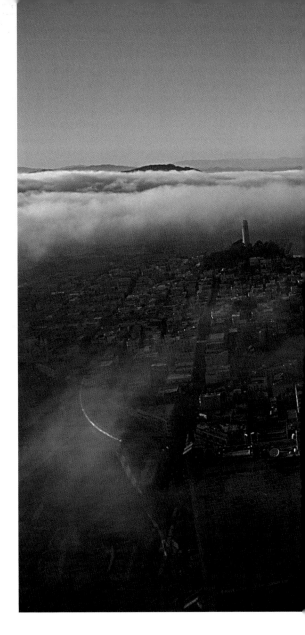

these two buildings is that you can shoot the Transamerica Pyramid effectively from the top of the Bank of America. From 3 PM on, assume your most sedate face, dress as much like a banker as possible, and maybe put your camera in a briefcase. (This is not the place for Bermuda shorts. The dignity of the setting en-

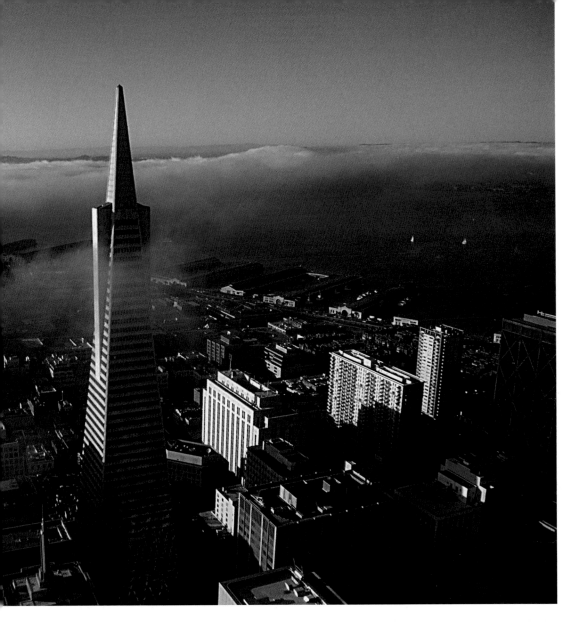

The Transamerica Pyramid as seen from the top floor of the Bank of America

courages one to look and act respectful.) Then proceed to the 52nd floor of the Bank of America building, and exit the elevator at the Carnelian Room, the highest observation point in downtown San Francisco. Order a drink and walk around to enjoy the views, which include looking out at the Transamerica Pyramid. Pull out your camera, and take a few discreet shots—if fog is swirling below you, the photos will be magical. Dinner starts here at 6 PM if you want to linger and prolong your opportunity to see the City and its potential fog theatrics unfold below you. Summer is the dramatic season for fog.

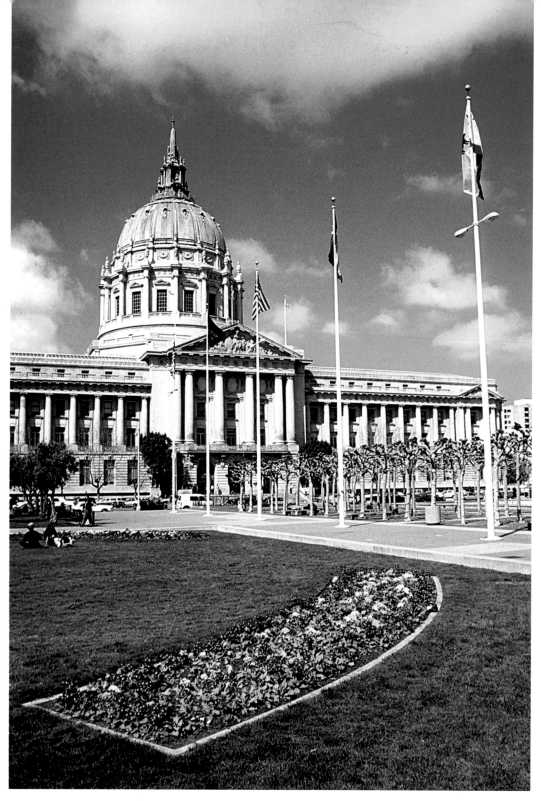

City Hall at the Civic Center Plaza

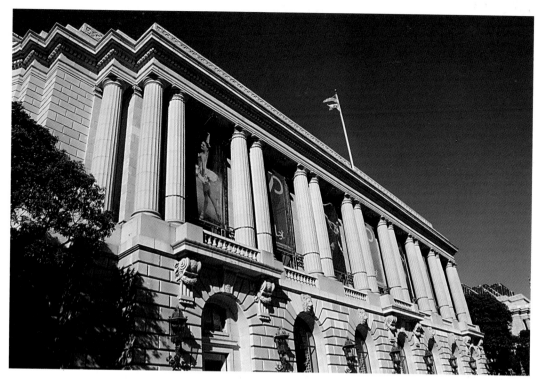

The War Memorial Opera House

Civic Center Area

The complex of government and cultural buildings known as the Civic Center, starting at Grove and Polk Streets, is another prime photographic target.

City Hall (15)

Start with the stately domed City Hall. (If you are traveling by BART, exit at the Civic Center Station.) City Hall is a Beaux-Arts masterpiece from 1915, replacing the earlier structure that was destroyed in the 1906 earthquake. As you look for special photographic subjects, the building's ornate and sinuous marbled staircases may intrigue you. Architect Arthur Brown Jr. was attentive to every detail, from doorknobs to the typeface for signage. If you have photographed in Paris, you will note echoes in this design from Les Invalides. The

spacious rotunda interior has been featured in many films, including *Raiders of the Lost Ark*.

The exterior of City Hall is a morning shot because the building faces east. If you are here on a weekday, you can enter the main floor to admire the rotunda and staircases. Expect security delays because of metal detectors.

Back outside, on Civic Center Plaza, the serendipity of San Francisco life may greet your camera. This great open space is a palette for the City's urban expression. You never know what you might see here, from a group of Chinese San Franciscans practicing tai chi to a farmers' market on Fulton Street, on the east side of the plaza.

Opera House/Herbst Theatre (16)

Across Van Ness from City Hall are the War Memorial Opera House and the Veterans

Building/Herbst Theatre, the two major performance venues in San Francisco. Here, again, these buildings are morning shots.

The buildings will engage a photographer who delights in architectural nuance and history. The War Memorial Opera House, completed in 1932, is another Beaux-Arts structure created by the noted architect Arthur Brown Jr. The exterior has somewhat severe Roman Doric columns, felt to be appropriate for the building's theme: honoring those who served in World War I. In 1945 the newly formed United Nations had its first conference here, and the UN Charter was signed next door in the Herbst Theatre.

Check to see if the Herbst Theatre happens to be open. If it is, you'll find such photo opportunities as a sumptuous and majestic foyer, fitting for grand performances, as well as eight large Beaux-Arts murals painted by Frank Brangwyn for the 1915 Panama-Pacific International Exposition.

Asian Art Museum (17)

On Larkin Street opposite City Hall stands the Asian Art Museum. This is one of the largest museums in the Western world devoted solely to Asian art. The collection is mainly the work of one remarkable man, Avery Brundage, who had both wealth and an appreciation of Asian art in the mid-20th century. The Asian Art Museum will intrigue the photographer who has an interest in anything Asian, especially at this time when we are preoccupied with all things Islamic, from Turkey on through Southeast Asia.

This august arts institution moved from its previous location in Golden Gate Park to this magnificent new building in 2003. When bathed in afternoon light, the facade of the museum is especially photogenic.

Once inside, you can walk through the collection with your handheld digital camera (no tripods, please), ramping up the ISO as may be needed to make exquisite available-light photos of the art objects for your personal insight, edification, and enjoyment. Prepare for your photographic foray with a look at the museum's Web site: www.asianart.org.

Main Library (18)

Also on Larkin Street (at Grove) is San Francisco's "new" Main Library. The $110 million structure, which opened in 1993, is a monument to modern-style library design and purpose—and one not without controversy.

Stroll inside and shoot some images of the focus of the controversy: some of the three hundred computer terminals that epitomize the vision of the role of today's library: assisting citizens in information retrieval. Of course, there are many shelves of old-fashioned cellulose books, the preservation and distribution of which is the traditional library mission.

Beyond the controversy, the airy atrium of the library is a masterpiece of modern urban design. Use your widest wide-angle lens to capture this special library landscape.

Federal Office Building (19)

"Green architecture" is another potential photographic specialty of the Civic Center area. After admiring the classic domed beauty of City Hall and its environs, meander across Market Street to Seventh and Mission Streets to gaze up at possibly the "greenest" new public building in America, San Francisco's new Federal Office Building. (Among other innovations: the 18-story building uses less than half the electrical power needed to sustain a comparable modern building. It has a natural ventilation system rather than air-conditioning.)

Grab a morning-shot exterior from Seventh and Mission. The public is not allowed inside the building, but the many energy-efficient aspects of the structure, such as baffles that cut

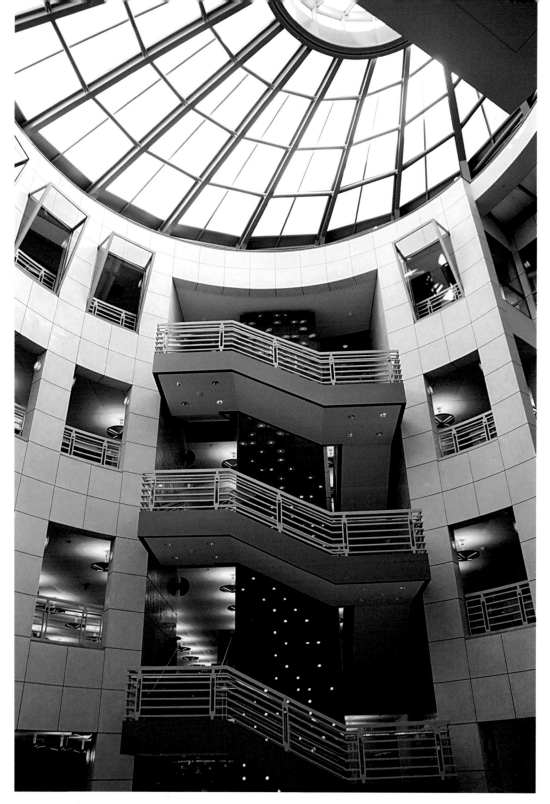

The innovative new Main Library at Civic Center Plaza

sunlight, can be appreciated from outside. Photographing the structure also captures an image of a "social experiment." The building's elevator stops only at every third floor so as to facilitate both employees' social interaction and their health in the walk up or down a floor to their offices.

A parallel cutting-edge "green" photographic quarry is the new **California Academy of Sciences** building in Golden Gate Park (see Part VII).

Grand Downtown View (20)

After perusing the various downtown locales, you may well ask, "Is there one place to go to make a stunning photo of this entire downtown?" The answer is: Twin Peaks, arguably the finest elevated photographic view of downtown San Francisco.

An afternoon-to-evening shot is optimal, since you are south of the downtown and the light will be coming in from the south and west. Get to Twin Peaks by car or taxi. (Public transportation access to Twin Peaks is challenging.) If you go in a taxi, ask the driver to hover, or get the cell callback number so you can arrange a pickup.

To reach Twin Peaks from downtown, head down Market Street until the straight southwest-heading street turns curvy. Wind

The new Federal Office Building, a model of "green" architecture

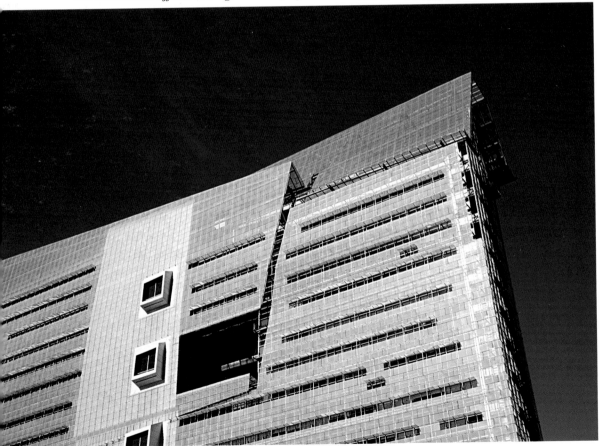

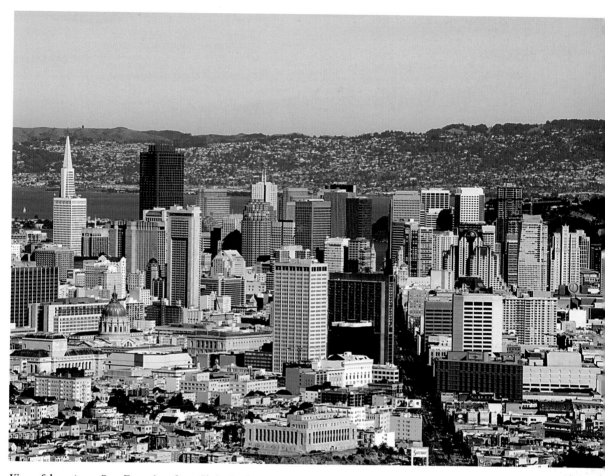

View of downtown San Francisco from Twin Peaks

around the curves until Market becomes Portola, and then go right on Twin Peaks. Parking is available on the promontory, but finding a spot may take a while. Word has gotten out that this is the best elevated view of San Francisco. You will be surrounded by a sea of humanity—and everyone present will have a camera. You may be charmed by the many families having their photo taken with San Francisco in the background. This is a happy place, and people are having fun.

Depending on the light, you may want to zoom onto the high-rise downtown area with a long lens, or make a wide-angle photo of the panorama, depending on whether your visual passion is the City itself or a quirkily tattooed person standing near you, looking at the view. Once you know this location, you may want to return because the changeable light of San Francisco will offer vastly different perspectives of this view for your camera. You may be here on a crisp and windy October day, with a totally pellucid sky. Or you may be here on a summer afternoon, and the fog may completely obliterate the view. Hopefully, you will be able to come back several times.

Be aware that this promontory can be windy and cold, so bundle up.

Yerba Buena Gardens Area

Good, sophisticated urban design includes satisfying green space and makes it rewarding to live in a city. San Francisco's Yerba Buena Gardens is just such a design concept, both for its cultural buildings and its 5½ acres of meadows, trees, flowers, and fountains, all of which are intriguing subjects to photograph.

A historical side note: The name Yerba Buena means "good herb" and referred to a plant with medicinal properties that was found in the area. It was also the original name of San Francisco when it was just a small community in the Mexican territory known as Alta California.

Museum of Modern Art (21)

If the architecture of a fine-art building is an artwork in itself, and this is your photographic passion, you must visit the San Francisco Museum of Modern Art, 151 Third Street. The current structure—announced by its distinctive round front window—opened in 1995, a creation of designer Mario Botta. However, the institution has had a special place in the culture of San Francisco since its founding in 1935 because it was the first museum on the West Coast devoted solely to 20th-century art.

If you want to photograph people and artwork or just the artworks of Pollock, Diebenkorn, Klee, Duchamp, and California's own photographic artist Ansel Adams as examples, this is the place. Any photographer might well enjoy seeing the significant photo collection of SFMOMA.

As might be expected, there are clusters of exciting art galleries around the great SF-MOMA property. One of them is **Chandler Fine Art** at 170 Minna Street. When I last dropped in, an opening reception was being held for the noted Kenyan American artist Jesse Allen and his primitivist paradise visions. Often artists welcome you taking a photo of them and their work at their opening receptions.

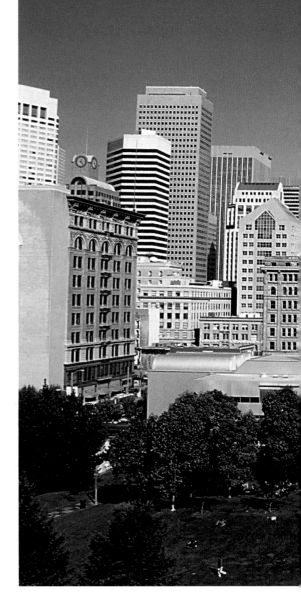

Yerba Buena Gardens (22)

Yerba Buena Gardens, located at Fourth and Mission Streets, is an easily identified large patch of greenery on any downtown map of San Francisco. Interesting urban design pho-

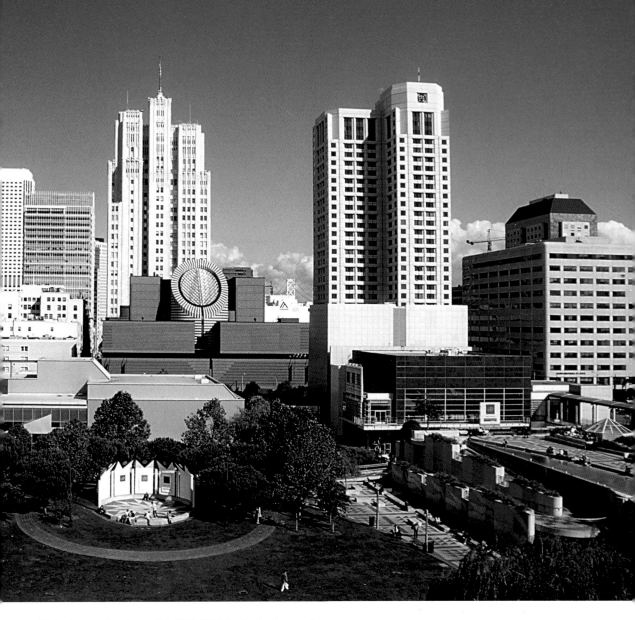

Yerba Buena Gardens with SFMOMA in the background

tos can be made here. Work with the circular shape on the SFMOMA building against the green grass and the fountains. A memorial waterfall honors Dr. Martin Luther King Jr.

Opposite SFMOMA and across Yerba Buena Gardens is the **Metreon**, whose elevated outdoor restaurants are good photo platforms to consider. The newest addition to this robust cultural scene is the **Contemporary Jewish Museum** at 736 Mission Street.

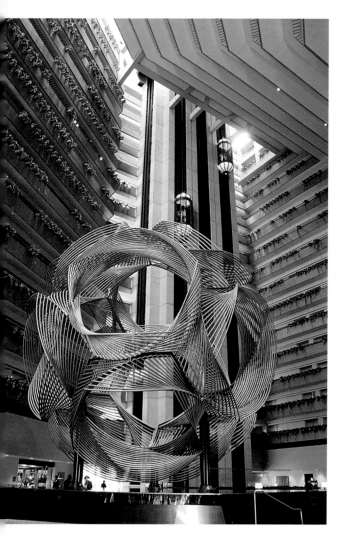

The lobby atrium of the Hyatt Regency

There is a lot to photograph in this intense area, and many interesting photos can be captured in this brilliant example of livable space in the midst of a major city. To get a better sense of what delights are to be found at this urban haven, visit www.yerbabuenagardens .com/features/gardens.html.

Hyatt Regency Atrium (23)

Among the major modern hotels with a visual feature designed to excite the photographer, the Hyatt Regency San Francisco, at Market and California Streets, is in a category of its own. The John Portman–designed structure near the waterfront emphasizes a breathtaking atrium lobby, the largest of its kind, according to *Guinness World Records*. You can lounge around in one of the lobby bars and contemplate your best photo option, which will be a wide angle. A standard or tabletop tripod is useful here because the interior is dark. Central to the lobby atrium photo is the art centerpiece, a Charles Perry sculpture called *Eclipse*. This twisting metal apparatus makes 4 tons of steel appear to be suspended effortlessly above a pool of water.

For a bird's-eye view, take the elevator to the top of the atrium, get off, and walk around to find some interesting perspectives and elements to photograph.

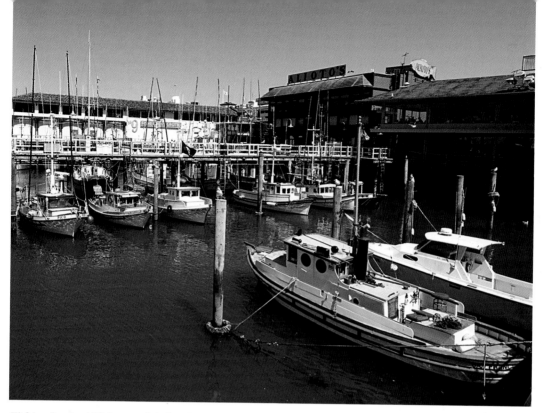

Fishing boats at Fisherman's Wharf

IV. Fisherman's Wharf, the Waterfront, and the Bay

The Fisherman's Wharf area presents the densest cluster of only-in-San Francisco photo ideas that you will find in the City. From here the gritty fleet of colorful fishing boats departs in search of the Dungeness crab and salmon delicacies that virtually beg to be consumed with sourdough French bread. An anchored fleet of historic boats also recalls the era when San Francisco was a world-class port. And the most robust example of tourist commercialism in the City can be indulged in at festive Pier 39. From the Fisherman's Wharf area, you will be tempted to take an excursion boat out on the water for an entirely different photographic perspective. Let's consider each of these photo possibilities in more detail.

Fishing Boats (24)

The fishing boats themselves, which can be seen at Jefferson and Jones Streets, are a defining visual of the scene. Dozens of these picturesque boats are moored in the small harbor. Unfortunately, this is a difficult time to make a living from fishing. (In 2008 the entire salmon fishing season was canceled by fisheries overseers because of the sharp decline in migrating

salmon in the Sacramento and Klamath Rivers.) One result is that many of these former commercial-fishing or charter-fishing boats now devote themselves to excursions. Therefore, if you want to venture out on the bay and photograph in a small boat rather than the large Blue & Gold excursion vessels, you now have other options.

Seafood and Sourdough (25)

You may want to sample and photograph some seafood in the Fisherman's Wharf area. The open-air vendors at Taylor and Jefferson Streets present a busy scene as they prepare and sell Dungeness crab, calamari, salmon, and shrimp.

Across the street at 160 Jefferson is the **Bistro Boudin** sourdough bread bakery, another major visual element. Photograph the bakers through the window, or go inside and take a tour, making images of this special San Francisco creation: sourdough French bread. You might also want to order a scooped-out round sourdough bread bowl filled with clam chowder and take it to the outside seating area, where you could both photograph it and savor it.

The 1886 square-rigger Balclutha *at the Hyde Street Pier*

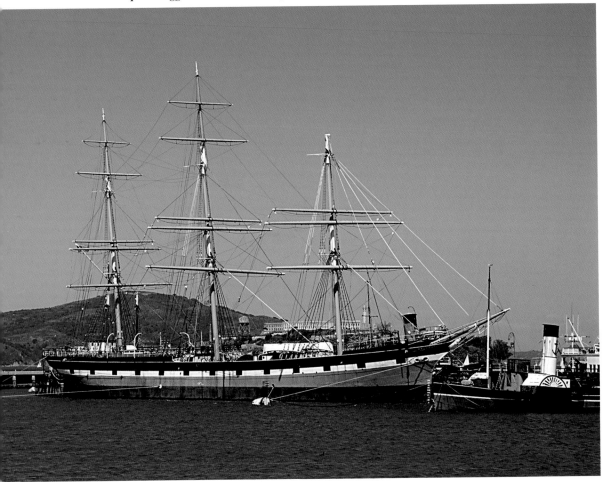

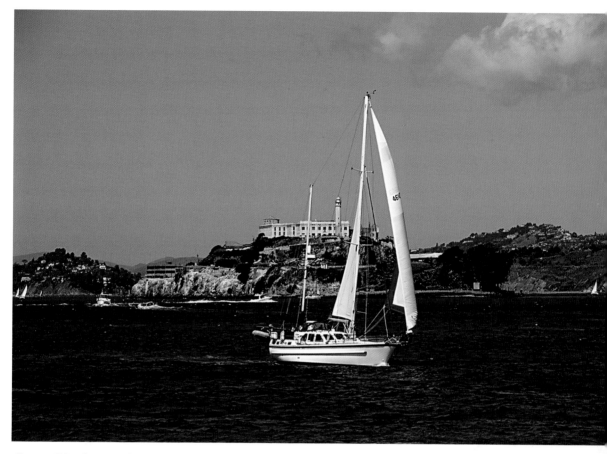

Alcatraz Island as seen from Pier 39

Hyde Street Pier/National Maritime Park (26)

Walk west a block on Jefferson Street from Fisherman's Wharf, and you will be able to aim your camera at several national historic treasures: the four surviving historic boats at the Hyde Street Pier, now protected by the National Park Service as the San Francisco Maritime National Historical Park. Stroll out on the pier and peruse the boats, then proceed across the street from the pier entrance to the excellent museum devoted to these boats.

You will have an opportunity to capture major maritime history and romance with your camera. Concentrate on the four vessels that are designated as National Historic Landmarks. *Alma* is a 59-foot scow schooner, built in 1891, used to carry hay and other products around the bay. *Balclutha,* a grand 256-foot square-rigged vessel, took California wheat to Europe. *C. A. Thayer,* vital in the lumber trade era, is now undergoing thorough restoration. *Hercules* was a steam-powered tugboat, escorting vessels around the bay.

Pier 39 (27)

Walk east a few steps from Fisherman's Wharf, and plunge yourself and your camera into one of the more vital tourism entities on the planet: Pier 39. Prepare to have a lot of fun.

Sea lions congregate at Pier 39

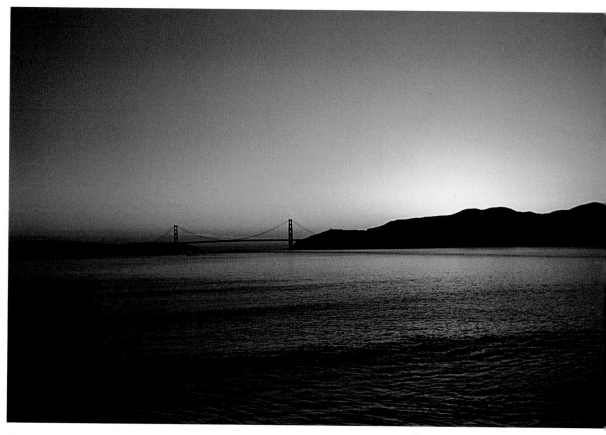

Sunset in the middle of San Francisco Bay

A serendipitous array of street entertainers is likely to greet you. I particularly enjoy the guys who paint themselves totally in silver to do their singing and dancing. A different kind of entertainment—the resident pinnipeds of Pier 39—are a favorite, if somewhat odiferous, attraction in themselves and can be viewed and photographed up close. These sea lions have overtaken the commercial slots for pleasure sailing craft. The window seats at the **Sea Lion Café** allow for both fine dining and a higher camera angle above the lolling sea lions.

Pier 39 is an elaborate complex of shops, restaurants, and entertainment venues, lively all year and particularly engaging at Christmas. A carousel and an outdoor theater may catch your photographic attention. Or walk out to the edge of the pier, where you have a direct shot at Alcatraz—perhaps with a lyrical sailboat skimming giddily past as a visual counterpoint to this monument of severe penal history.

Bay Excursions (28)

An excursion boat ride should definitely be on your photo to-do list. Get out on the water and aim your camera at the skyline of the City, the joyous sailing world of the bay, and, of course, the Golden Gate Bridge.

Every hour of the day will have a different set of light opportunities for photos as you look around 360 degrees. Chances are you'll get some good photos in at least one direction—

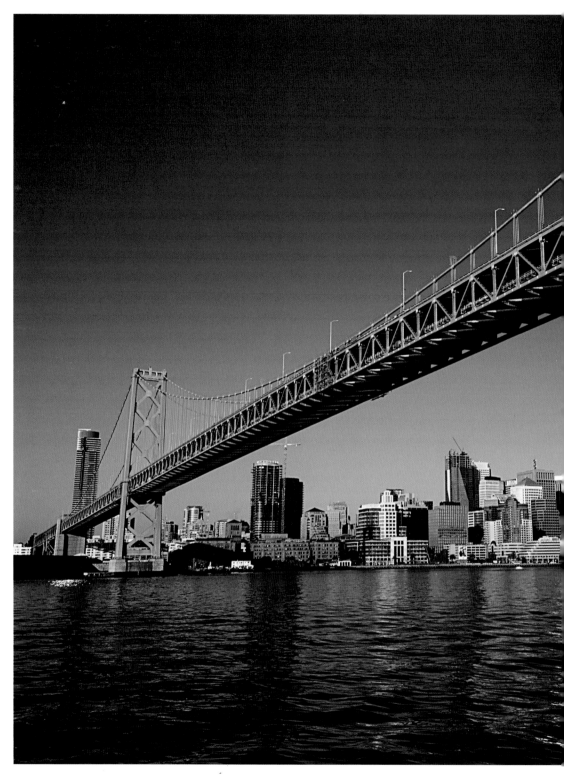

San Francisco skyline from early-morning ferry to Oakland

unless the fog gods look unfavorably on you (especially in summer). In early morning soft light falls on the downtown skyline and the bridge. By later afternoon the bridge is backlit—other than when your excursion boat heads to the west side of the span.

The main purveyor of these excursion trips is the **Blue & Gold Fleet**, just west of Pier 39. Other charter providers to consider are the **Red and White Fleet**, which sails from Pier 43½, and **Hornblower Cruises**, which offers a more posh sailing experience. Small fishing boats from Fisherman's Wharf will consider you the catch of the day if they can hook you and your party for a personalized trip out onto the bay.

Ferries (29)

Aside from "excursion" boats, aquatic photo opportunities can be found on the ferries that make regular runs over to Marin, Sausalito, Tiburon/Angel Island, and Oakland. A major cluster of ferries leaves from the Ferry Building at foot of Market Street, also known as the Embarcadero. The **Golden Gate Ferry** goes north to Marin County, while the **East Bay Ferry** sails over to Oakland and offers you the skyline of the City bathed in lovely light at dawn (see site 64). The **Blue & Gold Fleet** also has regularly scheduled ferry service to Tiburon and Angel Island, offering you multiple chance photographic encounters with sailboats, container ships, and bucolic landscapes.

Whether you choose an excursion cruise or a ferry ride, do appreciate the merit of getting out on the bay to photograph San Francisco and its environs from a fresh perspective.

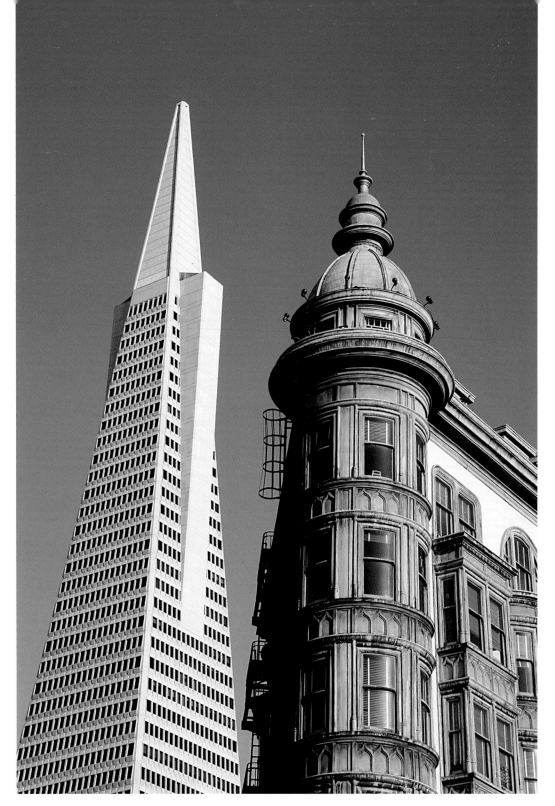

Old and new architecture: Sentinel Building and Transamerica Pyramid

V. Chinatown and Italian North Beach/Cameo Icons

Chinatown and North Beach are two San Francisco neighborhoods that have become iconic destinations unto themselves—if one judges by the number of visitors and the quantity of photos taken there. Fortunately for visitors, they are remarkably proximate to each other—making it easy to explore them together: walk up Grant Street in Chinatown, turn right when it ends, and immediately you are on Columbus Avenue in Italian North Beach.

Both neighborhoods need to be investigated on foot. You could easily spend a day prowling around here with your camera, perhaps morning for Chinatown—since the markets are more vigorous in the morning—and afternoon for North Beach, when a languorous hour of café idling may beckon the tiring photographer. Your pleasant dilemma in such a day's venture will be: in which culinary world will you choose to have lunch?

Aside from these unique neighborhoods, San Francisco also boasts three special smaller and much-beloved icons, each worth an hour of your photographic attention. Let's call them cameo icons. Immerse yourself in the Crookedest Street, Coit Tower, and the Ferry Building, and you will emerge with a somewhat better understanding of why life is fun, amusing, and interesting in the City.

Chinatown and Italian North Beach

Chinatown is roughly a 16-block rectangle bounded by Stockton, Broadway, Kearney, and Bush. Chinatown can only be experienced on foot. You need to walk around with your cam-

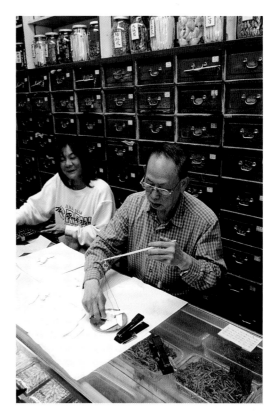

A Chinese herbalist

era until a suitable photo subject appears—which won't have you waiting long. North Beach is the Italian district of the city, located between Chinatown and Fisherman's Wharf. Here you'll find many Italian restaurants, bakeries, cafés, and grocery stores, all within a few blocks of Washington Square, the heart of North Beach.

Grant Avenue, Chinatown (30)

Chinatown's main street is Grant Avenue, between Bush and Broadway. A city within a city,

Chinatown is a fascinating place to browse—especially in the many small-scale shops that sell jade, porcelain, and silk.

One of my favorite places, at 1131 Grant, is **Yee's Restaurant**. Take a photo of roasted ducks hanging in the window, then enter this simple, modestly priced eatery for a tasty lunch of exotic meats, rice, and tea. Dishes will be set out on a large table. All this is OK to photograph, but be respectful and don't create a fuss. Make your choice and eat it there or take it out. The chefs may be cutting up a roast pig or cow tongue as you watch and photograph.

Typical of the many gift shops is the **Peking Bazaar** at 832 Grant. Silk fashions and ceramic art objects from China are interesting photo subjects. Also check out the **New China Book Store** at 642 Pacific Avenue, which carries a lot of literature and children's books from China.

Stockton between Washington and Broadway is where you'll find the largest concentration of food markets, exhibiting an amazing array of vegetables and meats. The vegetables, such as bok choy, are both interesting and unusual, and some food animals, like pigeons, are sold live. Two unusual photo subjects might be fat ducks hanging raw or cooked and paper-thin dried fish.

Washington Square/Italian North Beach (31)

Your best photo strategy is to casually walk around this area, staying within a few blocks of Washington Square, looking for shots. Many a milieu here, such as typical mom-and-pop places, might inspire you photographically. Often something interesting like an art show is taking place at Washington Square.

Many aspects of everyday life in North Beach can become beguiling photos. The **Italian French Baking Company** at 1501 Grant offers excellent taste as well as photographic

The poetry room upstairs at the City Lights Bookstore

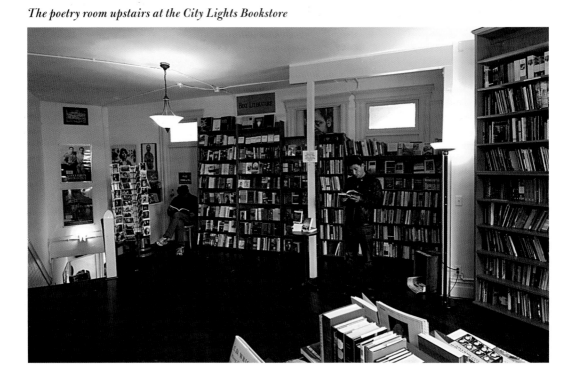

treats. For a cappuccino or glass of wine and some more interesting photos, pause at **Mario's Bohemian Cigar Store**, 566 Columbus. Interesting images abound at **Caffé Roma**, 526 Columbus, where all manner of coffee presentation, including specialty coffee-roasting equipment, can be found.

Then head a few blocks down Columbus to the most famous bookstore in San Francisco.

City Lights Bookstore (32)

The birthplace of the 1950s Beat movement, North Beach is the home of bookstores, galleries, small theaters, and nightclubs, all with photographic potential. Perhaps the most famous Beat venue is the City Lights Bookstore, 261 Columbus, which still thrives as a bookstore, publisher of local poets, and gathering place for writers. It is appropriate here to do casual, available-light, high-ISO photos rather than a tripod operation. Upstairs is the small Poetry Room, where performances are held and the shelves are stocked with such classics of the Beat period as Allen Ginsberg's *Howl*. Poet Lawrence Ferlinghetti launched City Lights in 1953, developing it first as a bookstore and reading site, then a publishing house.

American Zoetrope/Sentinel Building (33)

One of the most elegant buildings to photograph in North Beach is famed movie director Francis Ford Coppola's American Zoetrope headquarters in the historic Sentinel Building at 916 Kearny. Step across the street from Zoetrope, and you can make an image of San Francisco architecture old and new together, with the Sentinel Building in the foreground and the Transamerica Pyramid in the background. This classic San Francisco image has light on the structures in the afternoon. Coppola uses the building for his offices and a restaurant, **Café Zoetrope**, which features wines from Coppola's Napa Valley winery.

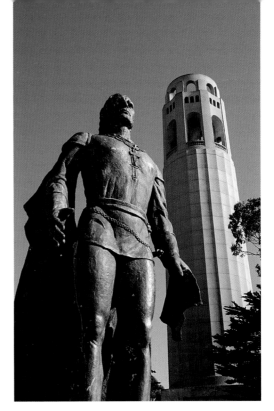

A statue of Columbus in front of Coit Tower

Cameo Icons

Aside from that blockbuster icon of icons, the Golden Gate Bridge, and major iconic neighborhoods like Chinatown and Italian North Beach, San Francisco boasts three special and much-beloved places that might be called cameo icons. These may already be on your photographic radar.

Coit Tower (34)

Coit Tower, which was Lily Hitchcock Coit's salute to her firemen friends, is atop Telegraph Hill, accessible from Lombard and Kearny Streets. A statue of Christopher Columbus in front of Coit Tower makes a good late-afternoon shot. Within the tower are interesting WPA-era idealized murals of a bucolic and industrious earlier California, which are worth a few photos.

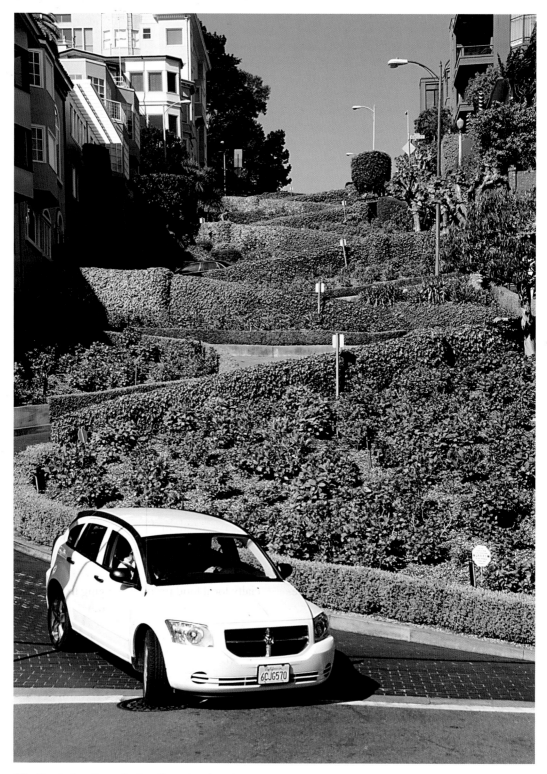

The Crookedest Street in San Francisco is a classic San Francisco photograph

If you are looking for a photographic theme, perhaps consider developing a portfolio of the City's lovely and historic 1930s murals. These at Coit Tower can be combined with parallel creations found at the **Beach Chalet** restaurant in **Golden Gate Park** and additional legacy visuals at the **Rincon Annex** on the east side of Market Street. Your detective work in seeking out the WPA murals of San Francisco could yield a rewarding collection of images.

Crookedest Street in San Francisco (35)

Lombard Street, the so-called Crookedest Street in San Francisco, winds its twisty way from Hyde to Leavenworth. You can get to the top of this zigzag phenomenon by taking the Hyde Street cable car and disembarking at Lombard. The Crookedest Street is not easy to photograph. From the top and bottom you are quite close, so it is difficult to get a sense of all the twists. The postcard photos you see of the full length of Lombard's switchbacks were probably taken from a neighborhood balcony or roof. Also, the residents have apparently lost their passion for lavish flower planting as the gardens appear in classic photos, so the current look of the Crookedest Street is of somewhat subdued green shrubs.

Ferry Building (36)

The restored Ferry Building, at the foot of Market Street, is unquestionably *the* glorious symbol of the newly revitalized Embarcadero on San Francisco's waterfront. Citizens who may feel ambivalent about the new sculptural elements on the waterfront are united in their intense love affair with this historic structure. The Ferry Building's clock tower is a major architectural icon. Another interesting image would be the Ferry Building with one of the colorful trolley cars passing by. San Francisco's transportation officials have gathered many historic and vintage trolley cars from around the world, sourcing them from Europe to Australia. The

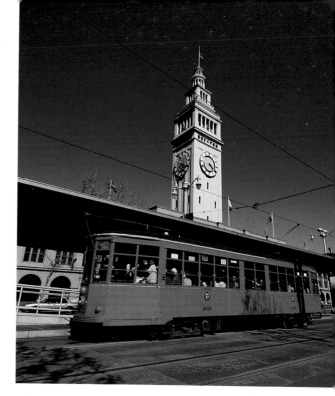

A historic trolley car in front of the historic Ferry Building

streetcars have been restored and put into service on the light-rail line running along the waterfront. They add a classy touch to the historic restoration of the Ferry Building. Afternoon light at 3 PM is good for this shot, putting the sun behind you, with strong illumination on the trolley and the Ferry Building.

Within the Ferry Building, upscale-boutique commerce now takes place, particularly of specialty local food products ranging from Berkeley's Scharffen Berger chocolates to specialty cheeses from Northern California. Or indulge in shellfish treats from the Point Reyes area at the **Hog Island Oyster Company**. This lively restaurant has a wonderful outdoor deck overlooking the water, where photographers can experience and photograph the Ferry Building, the bay, and the various aquatic culinary joys of Point Reyes.

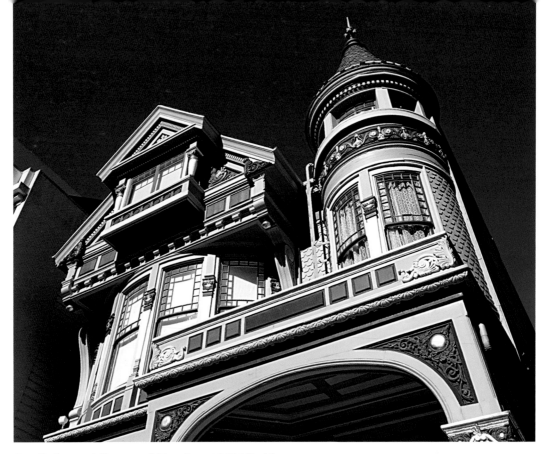

Detail of a partially restored Victorian at 1828 Pacific

VI. The Great Victorians

The "surviving" Victorian architecture of San Francisco is one of the major delights of the City to enjoy and photograph. San Francisco prospered enormously in the decades after the 1848 Gold Rush and the later Silver Rush, which occurred south of Reno, Nevada. Major fortunes were accumulated, especially in the so-called hard-rock mining era, when huge capital was required to set up a mine, and only a few people had the required resources. Other fortunes were made by people who built and controlled the railroads, which were central to the development and growth of the West. The "palace" Victorians of the wealthy and more modest Victorians of the tradespeople who served them became the warp and woof of San Francisco architecture.

The dramatic event that forever changed the landscape, of course, was the Great Earthquake of 1906. The quake itself did significant damage, but the conflagration *after* the quake wiped out an estimated 28,000 wooden buildings—sometimes entire blocks went up in flames, and sometimes random houses either succumbed or were sacrificed as firebreaks.

It is worth noting that the term "Victorian"

honors Britain's Queen Victoria and denotes popular architecture during her reign (1837–1901).

Alamo Square (37)

Alamo Square, seen from the corner of Pierce and Hayes Streets, offers one of the emblematic photos of San Francisco Victorians. Here you can see Victorians in the foreground with the more modern city in the background; this scene can be framed by the green lawn of the square itself. (You can determine whether architectural purity or the addition of people in the photo more suits your aesthetic goals.) This is an afternoon-to-sunset shot, with the sun in the western sky illuminating the Victorians.

Victorian San Francisco Driving Tour (38)

A driving tour allows you to see many of the prominent Victorian homes in San Francisco. The tour covers a considerable area, so it's best that you have a car or hire a taxi for an hour or so. Since some of the neighborhoods are chancy, walking is not recommended.

As you follow this precise driving tour, you may wonder why it's taking you past things like medical buildings and architecturally modern homes, not just Victorians. I wish I could satisfy your desires more compactly, but this is a reminder that the Great Fire following the Great Earthquake of 1906 had a logic of its own, hopping and skipping from place to place, sparing an island of architecture here and there and consuming others.

Furthermore, even in the 21st century Victorian San Francisco continues to evolve and improve. Spirited citizens tend to buy these structures and then outdo each other in their repairs and authentic restorations. Many of the houses are very colorful because the original paint schemes of the Victorian era were sometimes quite gaudy. In my 2008 review of this tour, for example, the house at **1828 Pacific Street** was being lovingly restored and

Alamo Square Victorians and the San Francisco skyline

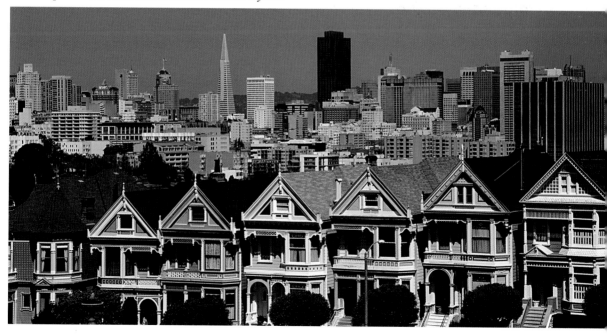

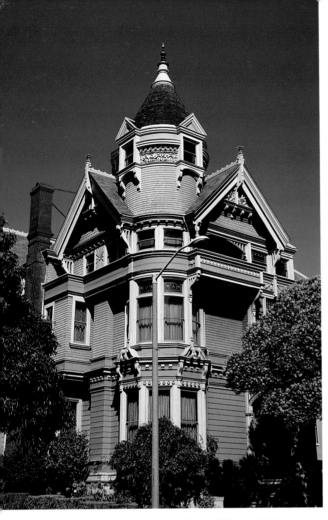

The stately Victorian Haas-Lilienthal House

made a beautiful photo with the morning sun full upon it.

To see a lot of Victorians, I recommend this route. (Remember that the scene will change from morning to afternoon because of shifting light—therefore consider repeating the tour at different hours.) Note that the tour takes advantage of one-way streets: Start at California and Franklin Streets. From the right (westbound) lane on California, turn right on Franklin, left on Pacific, left on Scott, left on Clay, right on Steiner, right on Sacramento, left on Divisadero, left on Golden Gate, right on

Scott skirting Alamo Square, left on Hayes, left on Steiner, left on McAllister, right on Scott, right on Bush, and left on Laguna to Union.

Got that?

Keep your eyes open on this tour. Victorian gems may appear to your right or your left, some monumental and others modest in size. And where fate intervened during the 1906 inferno, you'll be lucky enough to see and photograph a whole remaining cluster of lovely Victorians, such as the group at McAllister and Scott, near the end of the route.

Haas-Lilienthal House (39)

If you have time to look at only one Victorian, a prime example would be the Haas-Lilienthal House at 2007 Franklin Street, built for one of the founding families of San Francisco culture. The exterior of this spacious house is best photographed in late morning because of the surrounding vegetation. Summer rather than winter, with the sun higher in the sky, will help. You can also peruse and photograph the interior of the house during docent-led tours, which take place Sundays 11 AM to 4 PM and Wednesdays and Saturdays 12 to 3 PM. Call ahead for details at 415-441-3004. The house has a lived-in continuity, the presence of one family from the Victorian era to the mid-20th century. The sumptuous dining room and an upstairs child's playroom are the two most charming rooms in the house to photograph.

Best of all, however, is that the Haas-Lilienthal House is the starting point for walking tours of the Victorian zone. Call ahead, and sign up for one of these tours led by a knowledgeable guide. Many nuances about Victorians can be learned, and you could become a photographic sleuth with a collection of images depicting Queen Anne, Stick-Eastlake, or Italianate style. There was even a fad for eight-sided houses, and you can photograph the **Octagon House** at 2645 Gough.

Flood Mansion (40)

To view a parallel Victorian as impressive as the Haas-Lilienthal House, make the acquaintance of the Flood Mansion. This structure is in adjacent Nob Hill and is an example of Victorians in their most regal manner.

James Flood built this mansion at 1000 California Street in the company of several other barons of the railroad and mining eras, including Leland Stanford and Collis P. Huntington. Stanford was a hardware merchant in Sacramento when he partnered with Huntington, Mark Hopkins, and Charles Crocker to create the Central Pacific Railroad. These men knew how to arrange things so that wealth flowed to them. They were later joined in mansion building by the "Silver Kings" of Nevada's fabulously rich Comstock silver lode, including James C. Flood.

These highfalutin men—who were called "nabobs"—built their mansions atop a San Francisco hill, and thus the area was christened Nob Hill. The egalitarian fires following the 1906 earthquake played no favorites, however, and James Flood's mansion was the only structure of consequence on Nob Hill that survived. The house faces south, so it can be shot morning or afternoon.

The landmark Flood Mansion on Nob Hill

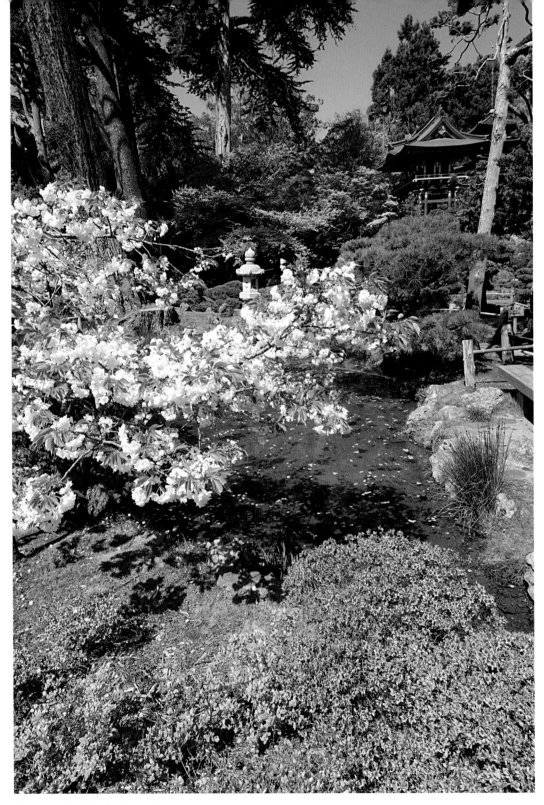

Japanese Tea Garden in spring

VII. Golden Gate Park and the Western Beaches

Golden Gate Park is the San Francisco equivalent of New York's Central Park—only bigger. When begun in 1877, Golden Gate Park was some 730 acres of sand dunes and another 270 acres of arable land scattered with oak trees. Today the park's 1017 acres stretch over lush meadows, a couple of man-made lakes, and even a Japanese tea garden. Within this huge rectangular green space flourish more than 6,000 varieties of shrubs, flowers, and trees, including dense stands of Australian eucalyptus and Monterey pine. Here the photographer can capture horticultural San Francisco at its finest.

Conservatory of Flowers (41)

The Conservatory of Flowers, a lavish Victorian greenhouse located near the east entrance to the park, easily ranks as one of the most photographable aspects of Golden Gate Park. Skilled gardeners are constantly attending the colorful flower beds in front of the building. Because the conservatory faces south and there are no visual obstructions, these flower beds can be shot from early morning to late afternoon. The plantings change with the season, so a photographer may wish to return here with each San Francisco visit. What is needed for photos, besides flowers, is a lovely blue sky behind the conservatory, and that is most likely to occur in April and May, then again in September and October. Summer fog can deaden the photo and may or may not burn off as the day progresses.

Few legacies of the Victorian era have a charm equal to that of the Conservatory of Flowers. The edifice opened in 1879 and is said to be North America's oldest existing public conservatory. The structure functions as a living museum, displaying many rare and tropical plants, including palms, orchids, and even carnivorous species. There is also a popular Butterfly Zone, where these delicate insects flit about. Many photographic close-ups can be made of lovely flowers arranged in such categories as Lowland Tropics, Highland Tropics, Aquatic Plants, Carnivorous Plants, and Potted Plants. A visit here is like a short trip into the tropical regions of the world.

If your photography passion includes collecting images of major places on the National Register of Historic Places, be sure to add the Conservatory of Flowers. Students of building design also admire how wood, not metal, was the construction material for this ingenious, lacy-looking building. The structure was badly damaged by a storm in 1995, but it was lovingly restored and reopened eight years later.

De Young Museum (42)

Located in the east central part of the park, in an area called the Music Concourse, the de Young Museum is the major repository of historic art in San Francisco. The de Young was recently rebuilt, and the modern design, sheathed in copper, is striking. Arrive in the morning to make a well-lit shot of the fountain and the tower on the east end.

Inside, large sculptures are scattered around the alfresco restaurant on the southwest side of the building, waiting to be photographed. Patrons wandering the galleries could also be the subject of photos.

The de Young Museum has elaborate col-

lections of historic art from America, Africa, Oceania, New Guinea, and Egypt, among other cultures. Close-ups of art objects might also be of photographic interest. The de Young is also a major venue for staging shows, such as a 2008 retrospective of the glass artist Dale Chihuly.

Be sure to check out the de Young's new

The sculptural new de Young Museum in Golden Gate Park

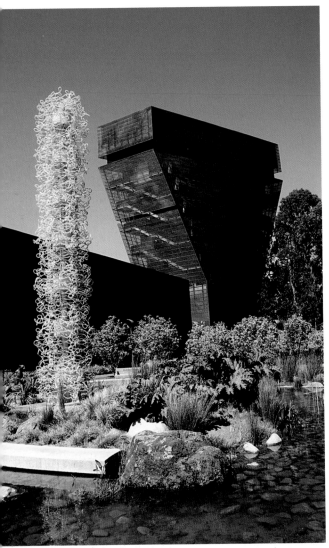

Observation Floor at the top of the Harmon Tower, where you can get a 360-degree view of San Francisco. An immense blown-up satellite map shows every lot in San Francisco. From this ninth-floor observation deck, you also get a lovely view of the new California Academy of Sciences, with its revolutionary "living roof."

California Academy of Sciences (43)

The California Academy of Sciences, opposite the de Young at the Music Concourse, has just been rebuilt and reopened in 2008. Photos of this remarkable world-class structure and institution could be part of your collection of "green" architecture images. Perhaps most notable when you approach the building is the striking curved roof—known as the Living Roof—which is composed of a variety of native plant species. You can take an elevator to the roof and step out onto the deck to photograph the roof up close. (A guide will be nearby and ready to answer your inevitable question: "Why would you want a living roof?")

The Living Roof is just one of the ecological design concepts inherent in the building. All the fish, penguins, and other creatures are presented in state-of-the-art facilities, including a four-story rain forest. This fresh and modern urban design was created by the Italian architect Renzo Piano. The Academy of Sciences has been a celebrated part of the park for 150 years. Incorporated into the building are the Steinhart Aquarium, Morrison Planetarium, and Kimball Natural History Museum. A range of photographic interests could be engaged here, both in the building itself and its displays, including architectural innovation, sustainability, environmental awareness, and, of course, the many creatures housed here.

The California Academy of Sciences is a unique institution, where you will see the best progressive thinking of Silicon Valley and other California entities at work solving the

real-world problems of energy and resource sustainability. Unlike "natural history" institutions of the past, with their interesting but somewhat dull collections, this institution is devoted to the "natural future." Prepare for your photographic foray to this remarkable place with a look at their comprehensive Web site: www.calacademy.org.

Japanese Tea Garden (44)

The Japanese Tea Garden, on the west side of the Music Concourse, was first built for the Midwinter Fair of 1894. Five acres of sculpted landscapes with bridges, ponds, miniature mountains, and bonsai plants greet the visitor.

The Japanese Tea Garden is a tranquil and meditative landscape year-round. However, you can photograph the setting with special delight in April and May, when its flowering plants are in their lush, spring growth. A planting of cherry trees flourishes within the garden and along the roadway immediately around the corner from the entrance.

Photographically, it is intriguing to walk around in the Japanese Tea Garden and isolate some compelling visual in your viewfinder or on your LCD screen and then capture it forever. Pause to take tea after a foray in the garden before returning to your visual quest. All kinds of light can be employed here to make pleasing photos. Fog and soft light can make the scene mystical.

Lands End Hiking (45)

The northwestern edge of the City presents images of open, wild landscapes. (It may also be the most likely site to subject your camera to salt and sand damage, so be careful to enclose your equipment in a plastic bag or a case when exploring here.) Known as Lands End, this northwest tip of San Francisco is being redeveloped as part of the Coastal Trail system, which provides ever finer opportunities to photo-

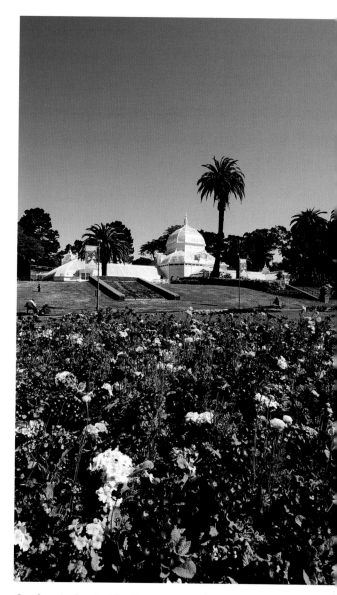

Gardens in front of the Conservatory of Flowers

graph and hike this special landscape. Park at the El Camino Del Mar Overlook, just up the hill from Seal Rock Drive, and enjoy this rustic scenery and the wild views of the Golden Gate Bridge. There are many trail amenities, such as steps in the steeper areas. You can hike and photograph here all the way from north of the

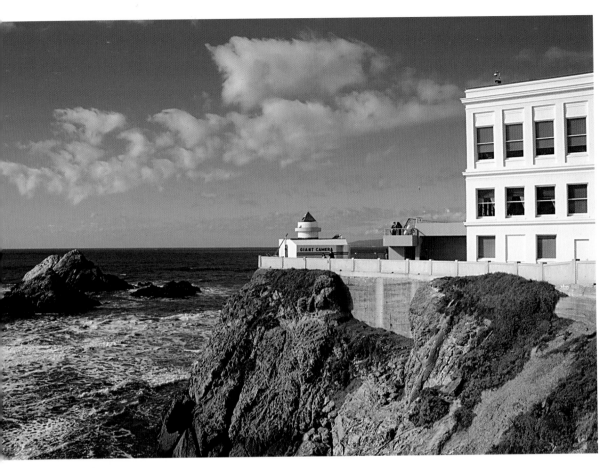

The Cliff House, overlooking Seal Rock

Cliff House (see the next entry) to the Golden Gate Bridge. Photo possibilities range from stunning ocean views to close-ups of the native California flora that has been reestablished here, including the aromatic blue flowers of the ceanothus bushes that blossom in the spring.

Cliff House/Sutro Baths (46)

South of Lands End, at 1090 Point Lobos Avenue, is the legendary Cliff House, now a fine-dining restaurant and formerly the site of the Sutro Baths. Offshore, amid the crashing surf, is photogenic Seal Rock. Inside the restaurant are large paintings depicting the immense Sutro Baths during the 1890s. The baths con-

sisted of several large, enclosed pools of seawater, making them a major "good-life" experience of the time, for socializing as well as for swimming.

Great Highway Windmill and Beaches (47)

As you head south along the Great Highway from the Cliff House, stop at the Dutch Windmill, at the intersection of John F. Kennedy Drive. This lovely windmill, erected in 1902, tells the story of the early effort to tame the shifting sands of Golden Gate Park and create a lush landscape. A huge amount of freshwater was required, supplied partly by this windmill, until electric pumps took over the task. The

manure from San Francisco's many horses was also beneficial to create the park's fertile soil. As you look at the miles of open beaches along the Great Highway, you can perhaps appreciate the challenge that John McLaren and the other park builders faced within the original sand-dune park.

Along the beaches, striking action photos are possible of the kite surfers being pulled through the waves with their airborne power. Sunset shots along the beach can be interesting. And, of course, people shots of dog walkers and sand-castle builders and just plain beach strollers will likely be on display for your camera.

Fort Funston Hang Gliders (48)

Farther south along the Great Highway, turn off at Fort Funston if you want to make action photos of the hang-glider culture that flourishes here. On any given weekend day a dozen hang gliders may be lazily riding the thermals along these cliffs. The gliders launch close to your viewing position, so close-up shots of the craft and the sky are possible, as are wide-angle land-scape photos of gliders with the sand cliffs and the ocean in the image. In fog, the setting can be quite ethereal. On a blue-sky day, the graphic element of a hang glider against the sapphire backdrop can be emphasized in your photos.

A hang glider launching into the fog at Fort Funston

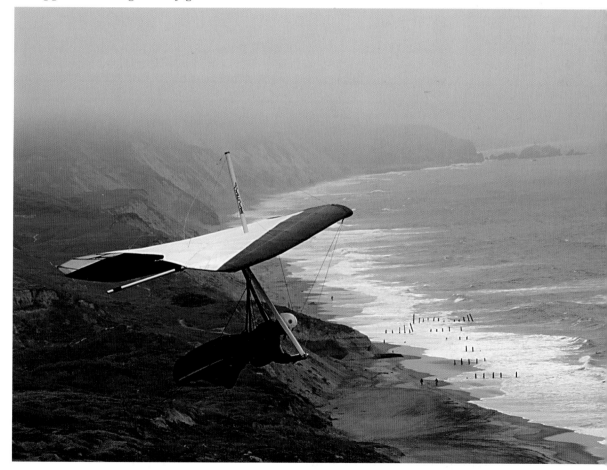

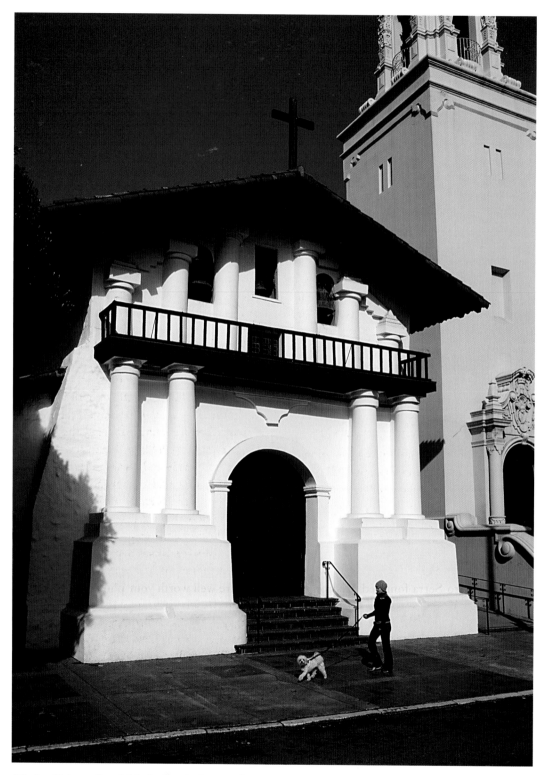

Mission Dolores, for which the district is named

VIII. Diversity: The Mission, Castro, and Haight-Ashbury Districts

Part of the photographic pleasure of San Francisco is exploring its neighborhoods. The City has a mostly low-rise footprint with many distinct districts, each with its own defining personality and clusters of unique habitats.

Three such neighborhoods show the diversity of the City. To photograph the Latino vitality of San Francisco, you would want to explore the Mission District. To consider a neighborhood built around the gay culture, the Castro District would be a good choice. Finally, one special neighborhood lives on in historic memory, Haight-Ashbury, a.k.a. the Haight. As you aim your camera there, the question will be: does it still exist today, even if you didn't come to San Francisco in 1967 with a flower in your hair?

The Historic Mission District

San Francisco was founded by Hispanics, as the city's name—Spanish for Saint Francis, the City's patron saint—suggests. It was started as a Spanish mission at a time when Spain wanted to establish a nominal presence in this vast, unexplored landscape.

Mission Dolores (49)

Father Junipero Serra founded Mission San Francisco de Asis, now called Mission Dolores, in 1776. The original whitewashed mission, at 3321 16th Street, is the oldest building in the City. A photo of the church and some of its artifacts is worth pursuing. Its facade will have good light in the morning.

The interior presents an interesting photo of the colorful altar and ceiling, both brightly painted. (The artistic paintings as well as the choral achievements among the natives in the early California missions were notable.) The light is low, so you will need a tripod or else ramp up the ISO on your digital camera. Be respectful of worshippers, and return at a more unobtrusive time if needed to take your shots.

In the mission's side garden is a re-created tule-thatched Indian house and the graves of several early San Francisco luminaries, including the first mayor. Here, too, you'll find a sculpted likeness of Junipero Serra.

Mission District Murals (50)

Aside from the Mission Dolores, another inviting photographic aspect of the district is the mural art that flourishes throughout the neighborhood. Information on the murals can be found at **Precita Eyes Mural Arts and Visitors Center**, 2981 24th Street. The nearest BART stop would be the 24th Street Station, which is five blocks down 24th from Precita Eyes. Buy their brochure *Mission Trail* and do a self-guided tour; better yet, take a guided tour with one of their art experts.

The Mission District murals constitute a major art form, both complex and delightful, and are well worth your photographic attention. Just a few doors down from Precita Eyes, **Balmy Alley** has more than 30 garage-door and fence murals, some dating back to 1971. Mural decor is used on many buildings, such as the **Taqueria El Farolito** and **Dominguez Mexican Bakery**, both at 24th and Alabama Streets, a few steps from Precita Eyes and the heart of this profoundly Hispanic center of

culture. Many of the murals are significant, world-class art, such as Joel Bergner's touching immigrant scene, *El Inmigrante,* at 23rd Street and Shotwell.

After admiring the mural at the taqueria, consider going inside and buying a shredded-chicken burrito or a taco, washed down with a bottle of Corona beer. Then walk across the street for a sugar pastry at the bakery. It is easy to imagine that you might be in Jalisco or Sinaloa, Mexico.

The Castro District

The Castro, San Francisco's gay bastion, offers an opportunity to photograph the neighborhood and the culture. The hilly Castro district is bounded by Douglas, Church, Duboce, and the crest of the hill at 21st Street.

The Castro: Gay San Francisco (51)

Begin exploring the district at Market and Castro, making your first stop the classic **Castro Theatre** (429 Castro), the restored movie palace that gives the area its name. The facade makes a pleasing photo when light falls on it in the afternoon.

Another afternoon shot is the exterior of the former camera store at **575 Castro** where activist Harvey Milk ran his business and lived upstairs. Milk, an important figure in the gay movement, was elected a city supervisor in 1978—the first openly gay person to be elected to any significant political office in the nation. Tragically, Milk and Mayor George Moscone were gunned down shortly thereafter by an irate supervisor named Dan White. This entire saga became the subject of a 2008 Gus Van Sant movie titled *Milk,* with many Castro denizens acting as crowd-scene extras. Today the camera store is a high-end gift shop. A bronze marker in the sidewalk cites Harvey Milk's legacy, identifying gay rights as an aspect of the civil rights movement.

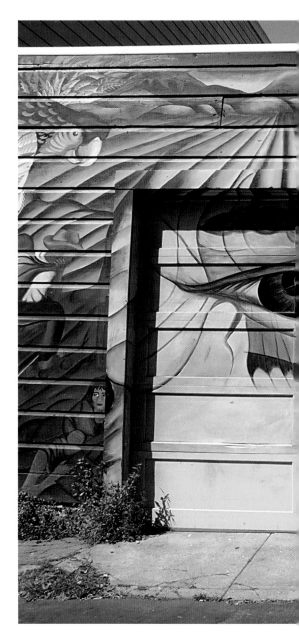

If you want to take a break from your tour to pause for food and drink while also absorbing the scene, make an appropriate stop at **Harvey's** at 500 Castro, in memory of the political activist.

One of the Mission's famous murals, this one—titled Indigenous Eyes: War or Peace?—*in Balmy Alley*

Gay Pride Parade (52)

The celebratory annual Gay Pride Parade—officially known as the Lesbian Gay Bisexual Transgender Pride Parade—is the best opportunity to photograph the gay scene. Those on parade are pleased to flaunt their identities, sometimes the more flamboyant the better. It is understood that anyone in the parade will not be camera shy, so photograph at will. The event is the last Sunday in June, beginning at

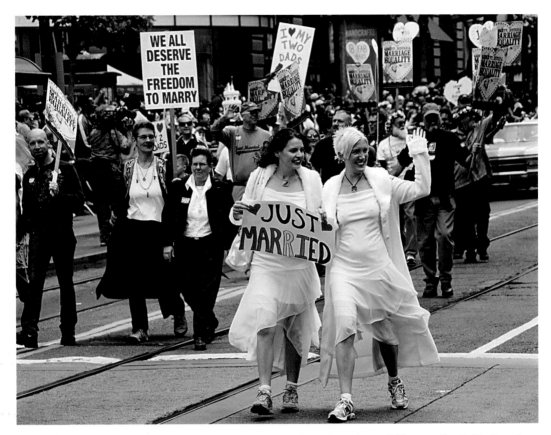

Revelers in the 2008 Gay Pride Parade—officially, the Lesbian Gay Bisexual Transgender Pride Parade

the Embarcadero and marching up Market Street to the Civic Center Plaza. This happening can only be described as an exuberant expression of out-of-the-closet gay and lesbian joy. Traditionally, the procession starts with Dykes on Bikes, a lesbian motorcycle contingent. Floats with plenty of well-built young men and booming music, stilt walkers, and groups of sign-carrying political activists are all part of the mix. Feel free to aim your camera at drag queens in stiletto heels as well as gay couples with kids in baby buggies. The Civic Center finale amounts to a giant block party. Looking ahead, photographs of the parade will serve to further document the controversy surrounding the definition of marriage.

The Haight-Ashbury District

Haight-Ashbury—a rectangle bounded by Oak Street/Golden Gate Panhandle, Divisadero/Castro, 17th Avenue, and Stanyan—presents a challenge. Can you photograph a scene from the past? Is there a visual legacy still alive in the Haight today? The answer is: maybe.

The Haight (53)

In 1967 San Francisco famously hosted the Summer of Love, an event that kicked off a decade of hippie counterculture energy. A flower-powered generation of long-haired dropouts from society came to the Haight for a dose of sexual freedom, psychedelic drugs, and rock-and-roll rhythms. Most were peaceful,

although the psychopathic killer Charles Manson also gathered his "family" at 636 Cole Street, prior to his 1969 spree killing of Sharon Tate and others in Los Angeles.

Today you can stroll the area with your camera and see whether an anachronistic hippie in a tie-dyed T-shirt wanders into range—though you're likely to see more tattoos and piercings that would ever have been evident back in the hippie heyday. Keep your olfactory sense alert for the pungently sweet smells of marijuana and burning incense. To absorb the action, walk Haight between Central and Stanyan.

Positively Haight Street, 1400 Haight, is a clothing and gift store that celebrates the spirit of the 1960s. Here you can see and photograph tie-dyed clothing, T-shirts from the concerts of the era, and posters. Typical patrons of the store are a new generation of parents wanting to pick out some little tie-dyed outfits for their youngsters.

A strong Eastern mysticism continues to pervade the Haight. This is evident in the clothing and art objects at **The Love of Ganesha**, 1310 Haight, or in the jewelry at **Dreams of Kathmandu**, 1352 Haight. At **Pipe Dreams**, 1376 Haight, you will indeed find pipes—a few thousand of them. All the merchants of these stores will allow photos if you are courteous and ask politely.

A bit of the contrarian spirit of the Haight lives on in the names of its stores, such as **Bound Together: The Anarchists Collective Bookstore** (1369 Haight). **Amoeba**, a music store at 1855 Haight, struggles to sell music on CDs in an era when downloads are taking over the business

Some lovely Victorian structures can be found in the Haight. Walk down Ashbury to south of Waller to view some nice examples of colorful facades. The Haight also boasts a wild and hilly **Buena Vista Park**, a sharp contrast with the flatness of nearby Golden Gate Park. This oasis of steep greenery is an invigorating area to walk. Some scenic views are indeed beautiful, as the Spanish name implies, especially where Duboce Road meets Buena Vista.

In the Haight, Jerry Garcia still lives

Dragons are emblematic of the Chinese New Year Parade

IX. Celebrations

Some of the best possible people photos in San Francisco can be created during festive annual events, when rituals of ethnicity and eccentricity are fully presented and celebrated. The revelers expect that a few thousand cameras are recording their antics, so there is little posed self-consciousness in the photos. Also, people at these celebrations often let themselves be photographed in public doing what they would not ordinarily allow you to photograph in private. Case in point: the many naked runners in the annual Bay to Breakers footrace. Crowd nakedness is remarkably easy and comfortable.

Here are three major annual celebrations that almost beg you to bring your camera.

Chinese New Year (54)

The annual Chinese New Year celebration in San Francisco is one of the most colorful and

vigorous ethnic celebrations in America to both photograph and experience. Though the Chinese were often discriminated against as they sought the right to live in California (and, later, the rest of the United States), their tenacity prevailed, and now they are a significant cultural influence in Northern California. An example of how far Chinese citizens have come in acceptance by the community at large is Heather Wong, who is the police chief of San Francisco as of this writing. During the 2008 Chinese New Year parade, she walked the route and shook every hand that was extended to her. A Beijing Olympics float in the same parade suggested the special prominence that San Francisco has as we proceed into a century in which China is a major force in the world: San Francisco was the only U.S. city where the 2008 Olympics torch was paraded.

The celebration day occurs rain or shine in late February each year as the Chinese lunar calendar dictates. (To plan your photo efforts, check for the precise date at www.sanfrancisco chinatown.com, which is a useful Web site for anyone wanting to photograph the overall Chinatown experience in San Francisco.) There are two aspects of the event to consider in your photo strategy: the daytime street fair on Grant Avenue between 9 AM and 5 PM and the night parade from 5:30 to 8:30 PM.

The street fair is nothing short of amazing. Grant becomes a choked freeway of humanity, even in a rainy year. Chinatown, always colorful, has a Kodachrome exuberance of people, food, crafts, and general human excitement. Grant is closed off all the way from California to Columbus, with side streets also closed. One of these, Washington, hosts an all-day musical venue that gets hundreds of people dancing in the street.

The parade itself is a world-class event— one of the great parades in America—that is telecast locally, nationally, and internationally.

Take advantage of the sophisticated lights that are set up high overhead at Union Square for the TV media to get your own great photos. Night will be turned into partial day. You can use available light and a ramped-up ISO on your digital camera as is needed. This is more aesthetically satisfying than a strobe shot.

Optimally, you should get to the Union Square area around 4:30 PM, about an hour before the parade begins, and commandeer a spot on the street, planning to tough it out for the next four hours to take in the full pageant. You may be able to advance purchase a bleacher seat at Union Square, arguably a good investment. If no bleacher seat is available, consider partnering with another photographer so you can leave your claimed position at the metallic police barricade for an occasional potty break at the Westin St. Francis Hotel. Few San Francisco events require such subtle photo strategy planning. The more you plan, the better your experience will be.

The parade itself is a three-hour pageant of Americana with a Chinese emphasis. Aim your camera especially at the dragons that appear at roughly 15-minute intervals. However, the opportunity for truly touching photos, especially of all the children in the parade, makes this event a moving one.

Every year in the Chinese zodiac calendar is represented by an animal. (2008 was the Year of the Rat.) A huge effort goes into crafting the appropriate animal costumes for thousands of individuals and creating the major floats. The year you photograph will be unique—unless you return 12 years later to see the same zodiac animal appear again in recycled form.

Carnaval San Francisco (55)

Carnaval San Francisco is the event of choice if you want to photograph the Latin flair of the City. Carnaval takes place in the Mission over

Memorial Day weekend, with the Sunday parade starting at Bryant and 24th Streets, then proceeding down to Mission. (Details are at www.carnavalsf.com.) Take the BART to the 24th Street exit—don't even try to drive a car there. Mission and 24th is a choice shooting location because there are no tall buildings to block the light when the performers turn to walk down Mission. Also, the energetic samba dancers are still fresh near the start of the event.

Begun in 1978, Carnaval is San Francisco's version of Mardi Gras. The event is organized by the Mission Neighborhood Centers as a benefit for charity organizations. The celebration attracts thousands of participants and partygoers. In recent years the event has become more inclusive. While Carnaval is primarily a Brazilian/Latin American/Caribbean festival, it is also multicultural and intergenerational. So expect some Chinese lion dances and some Japanese taiko drumming. However, the main event will be bands playing lively salsa and samba rhythms, with women dancing. Performers in skimpy sequined attire and feathered headdresses present the routines they have been perfecting for weeks. A king and queen preside over the sensual festivities after winning the hotly contested competition.

Bay to Breakers Run and Walk (56)

Bay to Breakers, one of the most famous footraces in the world, is an annual May event. (In this well-branded era, the race is now called "ING Bay to Breakers," named after the sponsoring finance company.) If you want to photograph wacky runners in a festive mood, this is the event for you. Actually, more people walk than run. The name reflects the traditional course, from the Embarcadero near the bay to the end point near the ocean "breakers" at Ocean Beach.

The 7.46-mile event attracts elite athletes, but it is mainly a party occasion for "fun-lov-

ing" runners and walkers who delight in parading through the City, many in ingenious fantasy costumes. It takes more than an hour just for the 65,000 participants in this pageant to cross the starting line. Standards of behavior are relaxed. About an equal number of entrants are pushing baby strollers as beer kegs. Large contingents run naked, some in a group called Bare to Breakers who are distinguished by their only attire, green hats. The event ends with a major party at the Polo Fields in Golden Gate Park.

A pedestrian bridge at the Convention Center on Howard Street makes a good elevated shooting platform from which to capture this surge of humanity proceeding near the start of the race. Details are at www.ingbaytobreakers.com.

Christmas in Union Square (57)

Christmas in San Francisco is a festive time, particularly in Union Square. Families will be enjoying the huge elaborately decorated Christmas tree in the middle of the square. Come evening the tree will be lit. Display windows at the major shopping stores around the square, such as Macy's and Saks, will be decorated, though the lavishness varies with the years. Also check out the lobby restaurant of the Westin St. Francis, which boasts a large spun-sugar Victorian castle, a favorite for children.

There's plenty to photograph around Union Square, including the Dickensian street entertainers who may be caroling for their seasonal tips. Note that handheld shooting works during the day, but you will want your tripod in the evening.

A yearly treat—photographically and otherwise—are the Christmas lights. One company that's a connoisseur of the lights throughout the downtown area is **Cable Car Charters**. Consider taking their hour-and-a-

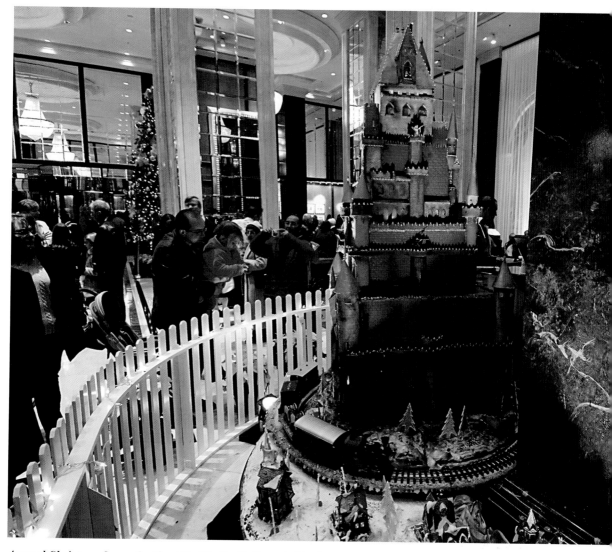

Annual Christmas Sugar Castle at the Westin St. Francis Hotel

half-long Holiday Lights Tour, riding in a motorized cable car that leaves from the south side of Union Square. Details are posted each November at www.cablecarcharters.com.

Christmas on Pier 39 (58)

Another rollicking site for Christmas celebration in San Francisco is Pier 39, which has a huge Christmas tree and a full program of car-

olers, choirs, and Dickensian entertainers cajoling shoppers into a cheerful mood.

Also on the Embarcadero is an ice-skating rink that is set up each year on **Justin Herman Plaza**, at the foot of Market. If you want to join the fun, don't worry if you're skateless; you can rent them on-site. To get night shots of the skaters you'll need to increase the ISO on your digital camera.

Amid the redwoods at Muir Woods

X. Beyond the City

A photographer wishing to explore beyond San Francisco has three appealing options. North of the City are the nature treasures of Muir Woods and Point Reyes. East across the bay, Oakland and Berkeley offer urban vitality. And south are both the cultural legacy of Stanford University and the bucolic possibilities of the San Mateo Coast.

Northward: Muir Woods and Point Reyes

For the nature photographer, Muir Woods and Point Reyes will provide an inexhaustible arena for photos. Both are accessible if you cross the Golden Gate Bridge and then head west on Highway 1, with Muir Woods at the 17-mile point and Point Reyes an additional 25 miles along twisty, rural roads with engaging seascapes. The drive out to Point Reyes alone is shorter—but less scenic—if you journey farther north and take the Sir Francis Drake Road west from Fairfax.

Muir Woods

Muir Woods Redwoods (59)

Head to Muir Woods to see and photograph majestic coastal redwoods, beloved by the ardent environmentalist John Muir, for whom this national monument is named. Parking can be tight along the road outside the entrance, especially on a weekend, so you may have to walk back quite a distance. Be sure to bring your tripod or else resign yourself to increasing the ISO on your digital camera. You will walk into the grove on a designated path and have good opportunities to photograph panoramic verticals of the redwood trees. If the light is foggy and soft, the redwoods will emerge in your

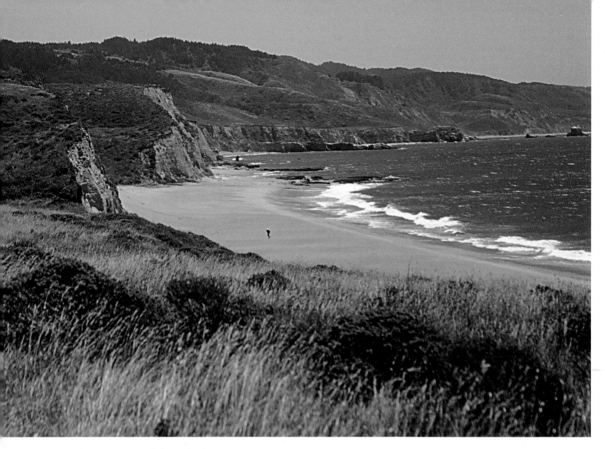

Limantour Beach in Point Reyes

photos with an even range of light throughout their branches. Close-ups of the understory plants, including ferns and sorrel, are other subject options. You may also want to photograph people on the path looking in awe at these magnificent trees. The hillside paths give you a higher perspective, allowing for wide-angle vertical shots showing the length of the tree trunks. This species of redwood is the tallest living thing on Earth, though the actual tallest coastal redwood trees are not here but rather farther north in California's Redwood National Park.

The redwood grove at Muir Woods has a hushed, sacred aura, with the choicest section appropriately called Cathedral Grove. The trees extend down a narrow valley with a stream—typical redwood terrain. Deep within the grove the light diminishes, which is why a tripod will be useful. Arrive at the park's 8 AM opening time to have the scene to yourself before the crowds start streaming in. In autumn you may be able to photograph coho salmon and steelhead rainbow trout migrating up this stream, called Redwood Creek. In summer the coastal fog drips off the redwood branches, providing a substantial amount of moisture as well as an ethereal feeling to photos.

Point Reyes

Farther west and north along Highway 1 is Point Reyes, which, like Muir Woods, is administered by the National Park Service. Stop in at the elaborate visitor center to orient yourself and plan your photo excursions.

Earthquake Walk (60)

One interesting photo possibility near the visitor center is Earthquake Walk, which shows the power of the Great Earthquake of 1906. Here you can make an image of a broken fence that snapped apart 13 feet when the earth offset slipped sideways.

Limantour Beach (61)

Expansive Limantour Beach and its immediate surroundings is one of the most diverse in Point Reyes for photos. The drive to the beach is itself appealing, passing through rustic forests and wild uplands. Arriving at the huge beach, consider aiming your camera at the saltwater estuary, or at people enjoying some of the area's favorite sports, especially hiking and bicycling.

Limantour Beach is vast. The surf is dramatic. Take off your shoes and get out in the surf for some striking photos. Limantour extends for miles, so purely scenic photos are possible. But even when people appear on the horizon, they can be intriguing players in your beach landscape.

Point Reyes Headlands (62)

To photograph a choice wildflower showing in April, drive all the way out to the Point Reyes Headlands Reserve near the Point Reyes Lighthouse. If you're visiting in January or March, this is also the place to photograph gray

Saltwater estuary at Limantour Beach in Point Reyes

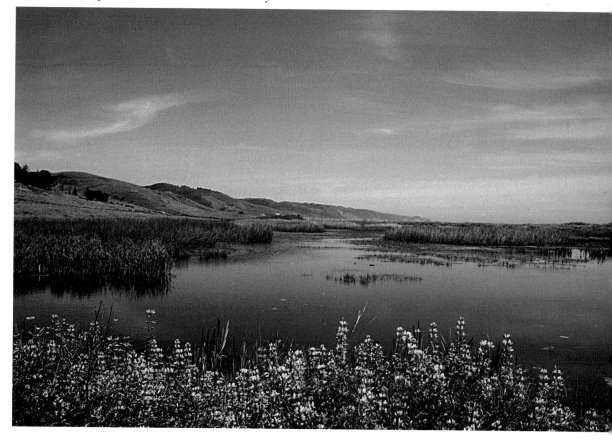

whales journeying between the Arctic and Baja California in their annual migration to give birth and mate in warm waters before returning to their summer feeding grounds off Alaska. (During the migration a shuttle bus runs regularly to help with traffic congestion.) The drive to the lighthouse passes through a pastoral cattle-grazing landscape and includes two magnificent drive-in beaches, **North Beach** and **South Beach**, which present dramatic surf opportunities for the photographer.

Yellow bush lupines are the choice flower in this area in April. You can photograph the yellow blooms with the ocean in the background. Close-ups of other native flora like the California poppy are also possible.

Pierce Point Road (63)

At its northern tip on Pierce Point Road, Point Reyes also presents an opportunity to photograph historic dairy farms and exotic tule elk. These legacy dairy farms have been maintained on this national park property, perpetuating a way of life that goes back to the 19th century. The tule elk is a magnificent California species that once was numerous but which was nearly annihilated in the 19th century. It was once thought that all the tule elk were hunted out, but a few survivors were found in a slough near Fresno. Gradually the herd was brought back from the brink of extinction. Now the tule elk numbers are stable, even growing. They have been placed at various reserves around

Yellow lupines at Point Reyes

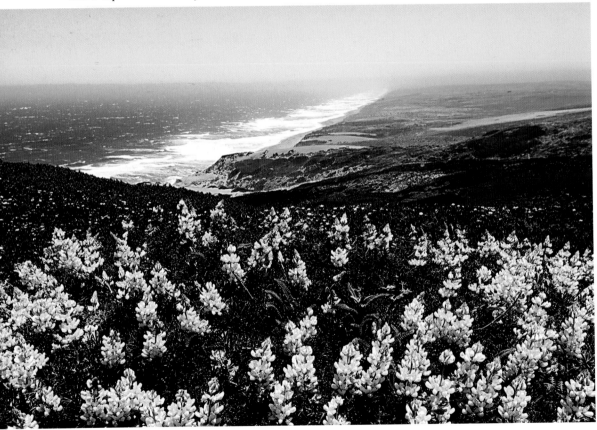

Container ship leaving the Port of Oakland

Northern California, such as Point Reyes and Grizzly Island, a wildlife preserve island in San Francisco Bay. You will want to employ your longest possible lens to get a photo of the herd or a magnificent lone buck with his stately rack of antlers.

Point Reyes could draw you back time and time again for different photo pursuits. The more you learn about this diverse landscape, the greater its potential photo beauty.

Eastward: Oakland and Berkeley

The trek from San Francisco to Oakland/ Berkeley happens to offer photographers the opportunity to capture one of the most unforgettable images of San Francisco possible (see site 29). Consider an early-morning departure from San Francisco on the **Oakland-Alameda Ferry** to Oakland. Your launch point is the Ferry Building. In early morning, San Francisco can be bathed in a luscious light. (Details for the ferry are at www.eastbayferry.com.) Alternative routes to Oakland are across the Bay Bridge or underneath the bay on the BART transit system.

Oakland

Port of Oakland (64)

The Port of Oakland, accessible to view as ferries pull in and out of Oakland, is visually exciting as one of the most vital container ports in the world. Possibly you will have opportunities to photograph a large container ship leaving the port, perhaps laden with Central Valley produce and fruits bound for China.

You will definitely be able to photograph the immense cranes on- and offloading the

containers for the large ships. Oakland has always been the East Bay's brawny counterpoint to brainy Berkeley, going way back to the literature of favorite son Jack London.

Downtown Oakland as viewed from Alameda, across the estuary

Jack London Square (65)

Writer Jack London—known primarily for his hugely popular man-against-the-elements Alaskan stories such as *Call of the Wild*—grew up in Oakland, which named this square at the ferry terminal in his honor. Wandering around the Jack London Square area can excite your visual imagination. If you're there on a Sunday, a vigorous farmers' market may be taking place. While on the Square, stop in at **Heinold's First and Last Chance Saloon**, where the young Jack London purportedly did some literary self-education, equipped with little more than a dictionary, when he was not out robbing the oyster fishermen of their catch.

There is a replica on the Square of **Jack London's cabin** from his Yukon days, which is quite authentic, as I learned from my own travels in the Yukon. A sculpture of London stands at the waterfront.

View from Alameda (66)

For a classic photo of Oakland, with the city in the background and possibly a few sailboats on the water, you would need to get over to **Alameda Island**, where you can drive along the waterfront roads to get various views. One good vista is from the boat slips in front of the **Pasta Pelican Restaurant**, 2455 Mariner Square Drive.

Your skyline photo may contain a number of elements, including kayakers and sailboats skimming by. Jack London Square is a central part of the background. The signature skyline building is the Oakland Tribune Tower. Though no longer home to the newspaper for which it was built and named, it remains an enduring symbol of the city itself.

Downtown Oakland (67)

Many aspects of downtown Oakland could be recommended for your photographic attention. A cluster of 16 Victorian homes, known as

Victorian Row, has been saved, their facades restored, at **Preservation Park**, 1233 Preservation Park Way. Victorian street benches, streetlamps, and a fountain complete the scene. Next door to the park at 672 11th Street is the **Pardee Home Museum**, a mansion that conveys the domestic life of one prominent family, the Pardees, who lived here for over a century, from 1868 until 1981.

Ramble around Oakland and you can photograph many diverse places, from its **Asiatown**, east from Broadway between 9th and 12th Streets, to **Old Oakland**, the historic district that features numerous bistros and boutiques. Parts of the downtown, west of 12th and Broadway, have been redeveloped into attractive high-rise office areas in this sprawling multicultural and multiethnic city. Downtown Oakland is also home of the outstanding **Museum of California**, at 1000 Oak. Its three display levels are devoted to California nature, history, and art.

Paramount Theatre (68)

Another celebrated and eminently photographable subject in Oakland is the lovely Paramount Theatre, 2025 Broadway. This gorgeous art deco lady from the 1930s is delightful from the outside, with a tiled mural facade, and even more beautiful on the inside, with exquisite art deco details. Walking through the Paramount takes you back to an era when movie theaters were indeed movie *palaces*.

When it was built in 1931, the Paramount had the largest seating capacity of any theater on the West Coast, accommodating some 3,476 people amid art deco opulence. Theatergoers can still enjoy such amenities as the wrought-iron Egyptian motifs and muted, rounded light fixtures so typical of the era. Photograph those details and build an art deco motif image collection.

No longer a movie theater, the Paramount is

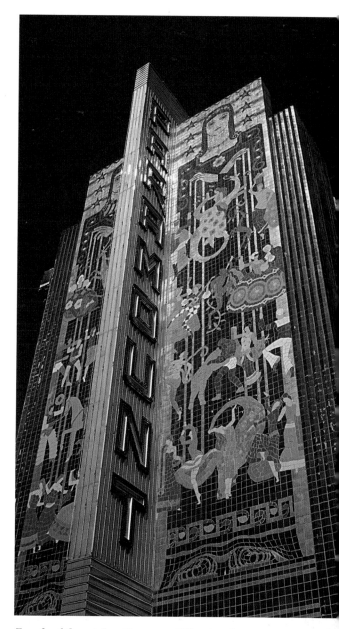

Facade of the art deco Paramount Theatre, downtown Oakland

now the signature musical venue for the city, hosting an eclectic mix of performances ranging from the Oakland East Bay Symphony to jazz and blues shows.

Detail of the Sather Gate at UC Berkeley

Berkeley

University of California (69)

Berkeley is the home of a sprawling photographic canvas, the University of California, one of the world's great centers of learning. UC Berkeley is within a few blocks walk of the Downtown Berkeley BART station. Start your exploration at Telegraph and Bancroft, and photograph the landmark portal to the university, **Sather Gate**.

Enter the campus and wander around, taking photos of the architecture and of modern student life. Other than Sather Gate, another prominent must-capture image is **the Campanile**, the tall tower that dominates the university landscape. If you want help identifying the most impressive buildings, guided walking tours of the university leave each morning at 10 from the visitor center in the Student Union.

Southward: Stanford and the San Mateo Coast

Stanford

Stanford University was a gift to Californians in 1891 from Senator Leland Stanford and his wife, Jane, as a reaction to a personal tragedy. The formal name of the institution suggests the basis of the gift: Leland Stanford Junior University.

Starting modestly during the Gold Rush as a merchant in Sacramento, Stanford Sr. managed to accumulate enough capital to become one of the partners who financed construction of the Central Pacific railroad over the Sierra Nevada. The success of the railroad brought him prodigious financial and political wealth. Stanford rose in Republican Party circles and was elected governor of California and then senator from the Golden State.

Hoover Tower, Stanford University

The Stanfords were traveling in Europe with their only son, Leland Jr., when he contracted typhoid fever and soon died in Florence. Following his untimely death (he was two months shy of his 16th birthday), the Stanfords decided to turn their 8,200-acre stock farm into a university so that "the children of California may be our children." Even today the cerebral establishment is referred to with affection by some as "the Farm."

Stanford University (70)

Located south of San Francisco, along the bay, Stanford University is another campus worthy of a photographic excursion. Two subjects to consider for images are the landmark **Hoover Tower**, home to a think tank, and the signature sandstone Romanesque architecture of the inner campus. Photos of the sandstone inner quad capture the original architectural design.

To get to Stanford, head south from San Francisco on U.S. 101. Turn west on University Avenue at Palo Alto. Drive through Palo Alto and onto the campus, parking at the large oval at the front of the campus.

San Mateo Coast

Many treats await a photographer driving south from San Francisco along the lovely San

Inner quad, Stanford University

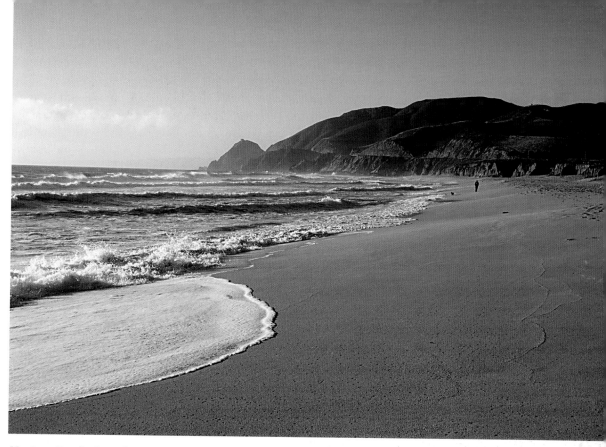

Montara Beach along the San Mateo Coast

Mateo Coast, from the natural beauty of area beaches to picturesque small towns to perhaps the most famous lighthouse in California

Montara Beach (71)

One particularly stunning natural scene to capture is the wide sweep of Montara Beach. There is a parking lot above the beach and some steep steps leading down to it. Because the beach faces west, your best shots will be in the visually magical hour leading up to sunset.

To reach the Montara Beach area, drive south down Highway 1, traveling along the ocean side of the coastal mountains. (Consider returning to San Francisco via the inland Stage Road to give yourself the full experience of both seaside and inland rusticity.)

Half Moon Bay (72)

The historic town of Half Moon Bay has some interesting small-town photo possibilities. **Cunha's Country Store** is a classic old-time general store, especially if you venture upstairs, where you'll find unpretentious straw hats, boots, and nondesigner blue jeans that they still sell to the area farm folks.

The **Johnston House** in the hills behind Half Moon Bay is an architectural gem, set alone in a large green field. This is a classic pre-fab house from the 1850s, created in New England, shipped around Cape Horn, and then floated ashore here in sections. The sections were then transported by horse-drawn carts up the hill, where the early settlers assembled the house.

Historic 1850s Johnston House in Half Moon Bay

Several picturesque coastal beaches and parks south of Half Moon Bay, such as **Bean Hollow**, merit photographic consideration, especially for images of wildflowers and rocky coastal surf.

If you visit in October, the annual **Pumpkin Festival** is a bumper-to-bumper affair because it's so popular, not only for its Halloween celebrations but for its arts/crafts, food, and music elements also.

Pigeon Point Lighthouse (73)

Continuing south on Highway 1, you will come to Pigeon Point and arguably the most photogenic—and also the most architecturally significant—of the many lighthouses along the California coast. Today all these lighthouses are historic icons, this one now serving as a youth hostel. But there was a time when crashing a ship into the coast was a major concern. Nearby Franklin Point is named after the Baltimore clipper *Sir John Franklin,* which went a-ground with major loss of life. Pigeon Point itself is named after the *Carrier Pigeon,* another ship that met an untimely fate on these rocks.

To take an especially engaging image of the Pigeon Point Lighthouse, come in spring and approach it from the south, with the wild yellow mustard and other spring flowers in the foreground.

Año Nuevo (74)

Just beyond Pigeon Point is the celebrated beach state park known as Año Nuevo. The special photographic quarry here is a pinniped, the elephant seal. They "haul out" or

A blanket of spring wildflowers at the Pigeon Point Lighthouse

climb onto the beach all year but in record numbers in winter. Elephant seals are huge animals, dramatic to photograph with a long lens. Do not approach them too closely, and in major haul-out times you may need to take a docent tour to get access.

The survival of the elephant seal is a major conservation success story. They were hunted for their blubber in the late 19th century, and their numbers were so thoroughly decimated that it was thought that the species was extinct. But a small colony survived on remote islands off Mexico, where the seal hunters missed their targets. Gradually, as a protected species, elephant seals expanded their range. Along the California coast, they gingerly inhabited offshore islands as they eyed the coastline. Everyone involved in the protection efforts for these pinnipeds felt the species would only be secure when they established birthing places on the mainland. I was fortunate enough to be at Año Nuevo in 1976 as part of the team of ecological cheerleaders celebrating the first recorded birth of an elephant seal on the California mainland in modern times. Today the species is totally secure, inhabiting beaches from Point Reyes to San Luis Obispo County. When a 2-ton bull elephant seal bellows in front of your camera, with its characteristic proboscis elevated to take on all comers, you will definitely get some strong action shots of an alpha-male animal. Details are at www.parks.ca.gov/?page_id=523.

All these sites along the San Mateo Coast are easy to find as you drive south along the coastline on Highway 1.

View the huge elephant seals at Año Nuevo up close with a ranger

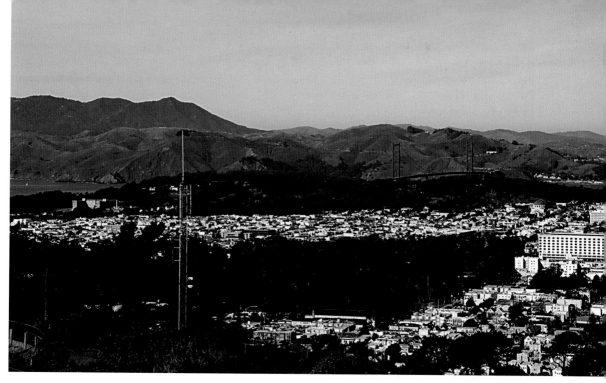

View of western San Francisco from Twin Peaks

Favorites

Favorite Perspective of Downtown San Francisco

The view from Twin Peaks (site 20)

Favorite Golden Gate Park Photo

The gardens in front of the Conservatory of Flowers (site 41)

Favorite View of Victorian Architecture

Alamo Square Victorians with the San Francisco skyline in the background (site 37)

Favorite View of the Golden Gate Bridge

From Baker Beach along the waterfront west of the bridge (site 3 and the cover photo)

Favorite on-the-Water View in San Francisco

The Golden Gate Bridge from a tour boat passing below the span (site 28)

Favorite Neighborhood Scene

The Precita Eyes murals in the Mission District (site 50)

Muir Woods redwoods

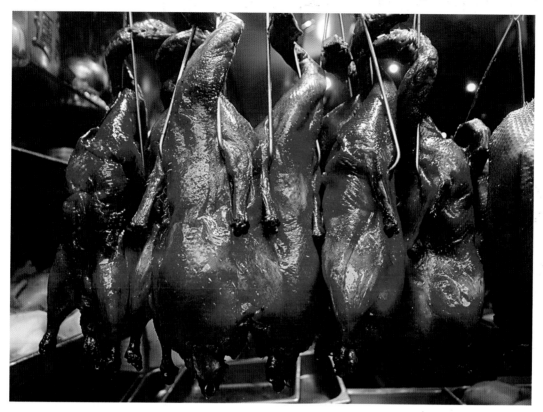

Ducks in Yee's Restaurant window, 1131 Grant

Favorite Beyond-the-City Image

Muir Woods coastal redwoods in all of their vertical splendor (site 59)

Favorite Celebration Moment

The 60,000-plus runners and walkers at the start of the Bay to Breakers race (site 56)

Favorite Chinatown Detail

Roast ducks hanging in the window of Yee's Restaurant (site 30)

Favorite Cable Car Photo Location

The Hyde-Powell line as it climbs Hyde Street toward Chestnut Street (site 8)

Useful Web Sites

Overall tourism info for San Francisco, of obvious interest to the photographer, can be found at www.onlyinsanfrancisco.com. The walk-in traveler information center sponsored by the San Francisco Convention & Visitors Bureau at the BART station at Hallidie Plaza (Market and Powell Streets) is a source of free maps and information.

The GGNRA (Golden Gate National Recreational Area) is the National Park Service entity managing many aspects of the outdoor world in and around San Francisco. See www.nps.gov/goga.

Everything about cable cars can be reviewed at the Cable Car Museum Web site at www.cablecarmuseum.org.

The great art and culture institutions of San Francisco are worlds unto themselves. Information about the San Francisco Museum of Modern Art (SFMOMA) in the Yerba Buena Gardens plaza area is at www.sfmoma.org. The Asian Art Museum of San Francisco, in the Civic Center Plaza area, is presented at www.asianart.org. For the Golden Gate Park and Lincoln Park areas along the western edge of the City, the de Young Museum and the Legion of Honor have information at www.famsf.org.

The newly opened California Academy of Sciences in Golden Gate Park has a wonderfully comprehensive Web site at www.calacademy.org.

Getting out on the bay is a critical part of your San Francisco photo opportunity. Some providers of excursion cruises and ferry trips can be found at www.blueandgoldfleet.com, www.redandwhitefleet.com, www.hornblower.com, www.goldengateferry.org, and www.eastbayferry.com.

Info on San Francisco's Chinatown and the Chinese New Year celebration is available at www.sanfranciscochinatown.com.

For an introduction to the Victorian architectural heritage of San Francisco, visit the Haas-Lilienthal House Web site at www.sfheritage.org/house.html.

Get a preview of the highly photogenic murals in the Mission District at www.precitaeyes.org. The Mission District is also home to the colorful annual Hispanic celebration known as Carnaval San Francisco. Find out more at www.carnavalsf.com.

The exuberant run/walk annual event known as Bay to Breakers can be perused at www.ingbaytobreakers.com.

Enjoy a tour of the City's Christmas lights by checking out www.cablecarcharters.com. Their Christmastime info goes up on their Web site each November.

Nature photographers can bone up in advance on the main features of Muir Woods and Point Reyes at www.nps.gov/muwo and www.nps.gov/pore.